TO FLY *CONTEMPORARY AERIAL PHOTOGRAPHY*

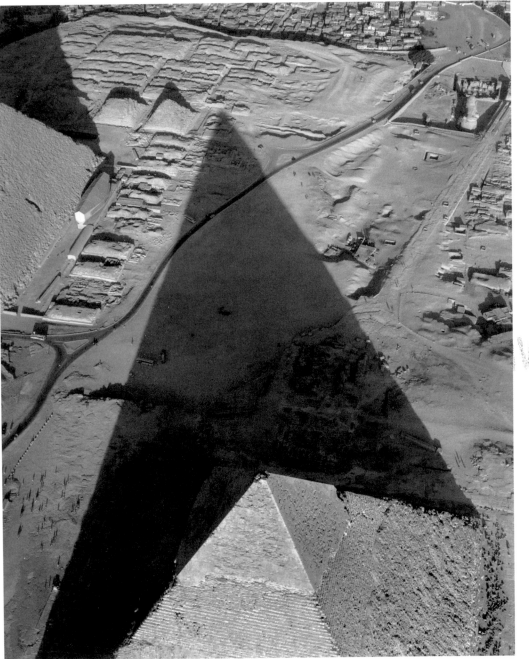

TO FLY

CONTEMPORARY AERIAL PHOTOGRAPHY

Exhibition and Catalogue by Kim Sichel

BOSTON UNIVERSITY ART GALLERY

SEPTEMBER 7–OCTOBER 28, 2007

ON THE COVER: Detail of David Maisel, *The Lake Project #2*, 2001-2003, C-print, 29 x 29 in., courtesy of the artist and Miller Block Gallery, Boston, MA.

FRONTISPIECE: Marilyn Bridges, *Pyramid of Khephren, Giza*, 1993, gelatin silver print, 24 x 20 in., courtesy of the artist

Boston University Art Gallery
855 Commonwealth Avenue
Boston, Massachusetts 02215
617-353-3329
www.bu.edu/art

Distributed by University of Washington Press
P.O. Box 50096
Seattle, Washington 98145-5096
www.washington.edu/uwpress

Printed in the United States of America
Library of Congress Control Number: 2007924377
ISBN: 1-881450-26-0
ISBN-13: 978-1-881450-26-9

CONTENTS

ACKNOWLEDGMENTS

The Boston University Art Gallery (BUAG) is delighted to present *TO FLY: Contemporary Aerial Photography*. The exhibition and accompanying catalogue explore the diverse manifestations of aerial photography in contemporary art, as well as the historical context that led to its development. As an important contribution to the study of aerial photography, *TO FLY* builds on BUAG's long-standing commitment to photography and reunites us with Kim Sichel, Boston University Professor of Art History, as curator of the exhibition. Professor Sichel has organized several key photography exhibitions for BUAG over the years, including *From Icon to Irony: German and American Industrial Photography* (1995), *Black Boston: Documentary Photography and the African American Experience* (1994), and *Mapping the West: Nineteenth-Century American Landscape Photographs from the Boston Public Library* (1992). We thank her for providing the intellectual leadership that guided the exhibition and publication to completion.

We would like to thank the members of Professor Sichel's 2006 curatorial seminar for their research and contributing the artist entries to this project: Mark Binford, Sadie Bliss, Gioia Brosco, Dorothy Nieciecki, Kate O'Neill, Ariel Pittman, Jessica Roscio, Meghan Sheridan, Ginger Elliott Smith, Alyssa Spadoni, Tina Tsai, Katharine Urbati, and Christopher Woodhouse. Lisa Sutcliffe was an invaluable research assistant in the project's early planning stages. Ginger Elliott Smith and Ben Charland have been essential collaborators during every phase of the exhibition's development. Our sincere appreciation goes to Marc Mitchell, BUAG's Assistant Director, for his management of the exhibition and publication, and for overseeing the installation process itself. We also thank BUAG staff members who provided valuable support, including Kaia Balcos, Evelyn Cohen, Seth Gadsden, Rebecca Hoosier, Paul Kadish, Samantha Kattan, Nilda Lopez, Karen Ann Myers, Natania Remba, Leann Rittenbaum, and Lana Sloutsky. Thanks are also due to Chris Pierson for his skillful editing of the text.

We appreciate the support of the Boston University Humanities Foun-dation, the Kate and Hall Peterson Fund for Photographic Studies at Boston University, the Art History Department, and colleagues in the department, as well as Dr. Farouk El-Baz, Director of Boston University's Center for Remote Sensing. We thank the artists in the show for sharing their work and ideas with us. Barbara Bosworth, Emmet Gowin, Adriel Heisey, David Maisel, Marilyn Bridges, Frank Gohlke, and Sophie Ristelhueber have generously donated time and insight to the show's development. We are also grateful to Olivo Barbieri, Esteban Pastorino Díaz, Terry Evans, and Alex MacLean for their cooperation. Additionally, we are fortunate to include the work of Bradford Washburn, William Garnett, and Mario Giacomelli in the exhibition. Numerous people and institutions have greatly assisted us with loans and collaborations, including Barbara Hitchcock at the Polaroid Collections, Waltham, and the Albright-Knox Gallery, Buffalo. We also thank Ellen Miller and Miller Block Gallery, Boston; Robert Klein and Robert Klein Gallery, Boston; Tony Decaneas and Panopticon Gallery, Boston; Tracey Norman and Yancey Richardson Gallery, New York; Catherine Edelman and Catherine Edelman Gallery, Chicago; Missy Finger and PDNB Gallery, Dallas; Danielle McCarthy and Landslides Aerial Photography, Cambridge; and William Allan Garnett, Trustee of the William A. & Eula Beal Garnett Trust.

Finally, Kim Sichel would like to thank fellow curators and scholars of photography and aeronautics who have shared their knowledge about aerial photography over the last several years, including Kent Christman, Jodi Cranston, Elizabeth Edwards, Ute Eskildsen, Patricia Hills, Anne Leyden, Allison Nordstrom, Françoise Reynaud, Hillary Roberts, Joan Schwartz, Sarah Stevenson, Ann Tucker, Ricardo Viera, Enrica Viganò, and Deborah Willis.

STACEY McCARROLL CUTSHAW
Director & Curator
Boston University Art Gallery

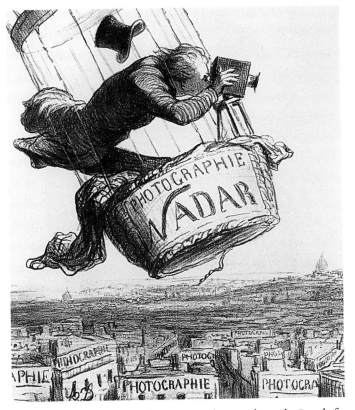

1. Honoré Daumier, *Nadar Raising Photography to the Level of Art*, 1862, lithograph

TO FLY: CONTEMPORARY AERIAL PHOTOGRAPHY
Kim Sichel

INTRODUCTION

When Honoré Daumier drew a caricature of Nadar leaning out of his balloon to aim his camera down at Paris below him (Figure 1), he was echoing a widespread interest in a new kind of vision—photography from the air. Nadar, a passionate balloonist as well as mid-nineteenth century France's leading portraitist, first successfully photographed France from the air in 1858.[1] These two modern technologies—aeronautics and photography—have remained inextricably linked ever since. Photographers have continued to be fascinated by flight, and the images they made have continued to change our perceptions of the world we live in.

Although Daumier's drawing shows Nadar hovering above a conventional landscape, complete with perspectival recession and a horizon line, Nadar's photographs differ radically from any previous landscape or cityscape. His views of Paris (Figure 2) and James Wallace Black's 1860 view of Boston from a balloon (Figure 3) pioneered a completely new visual depiction of the earth, one that has been eagerly developed by photographers up to and including the NASA astronauts who first photographed Earth from spacecraft in the late 1960s, and extending all the way to our current obsession with Google Earth and the opportunity to spy on our own homes from satellite images.

By focusing on fourteen contemporary artists, this book explores a wide range of aerial photography against the backdrop of the scientific and historical imagery that preceded it. The photographers come from Argentina, France, Italy, Switzerland, and the United States, and their subjects span the globe. This international group includes three seminal mid-century photographers: Bradford Washburn, Mario Giacomelli, and William Garnett. Washburn pioneered mountain photography, photographing glaciers in Alaska and around the world from his airplane. Giacomelli created emotionally charged abstract patterns from the fields of the Italian countryside. Garnett photographed the American western landscape in an elegant and spare series of geometric patterns.

Some of their more contemporary colleagues continue to work in black and white. Marilyn Bridges travels all over the world to document archaeological sites from the air, highlighting the dramatic shadows of sites in South America, Europe, and Egypt. Frank Gohlke engages with the destructive powers of Mount St. Helens' eruption and the regrowth of the following decade, returning over and over again to the site of the volcano's damage over a ten-year period. Emmet Gowin travels all over the world to record from the air the marks of environmental destruction, albeit in a lyrical formal language that seems to leave active politics behind. Barbara Bosworth photographs an ethereal topography by shooting downwards from commercial aircraft with her 8x10-inch camera to create landscapes of clouds.

Other contemporary aerial photographers employ color imagery to address a wide range of issues. Alex MacLean flies his plane over a variety of places that he reduces to geometrical colored patterns, and his work comments on the visual borders between land uses. Terry Evans works with various conservation groups around Chicago to document the flat views of the Midwestern landscapes of field, city, and Lake Michigan around Chicago. Adriel Heisey builds his own planes and hangs outside of them to document Native American sites such as Chaco Canyon from a low altitude. David Maisel reengages with Robert Smithson's ideas of earthworks, creating a formal dialogue with Smithson's *Spiral Jetty* sculpture as he photographs the Great Salt Lake and other dried-up lakes such as Owens Lake in California, transforming them into brightly colored geometric patterns. Italian photographer Olivo Barbieri surveys Rome and other cities from a helicopter, and makes videos that pair the imagery with video footage and soundtracks of beating propellers and lyrical Italian songs. Argentina-born Esteban Pastorino Díaz photographs the landscapes of South America and Greece by using a kite with a camera mounted beneath it. Finally, the French artist Sophie Ristelhueber uses aerial images to make a graphic

2. Félix Tournachon Nadar, *Aerial View of Paris, Arc de Triomphe*, modern print from a negative of 1868

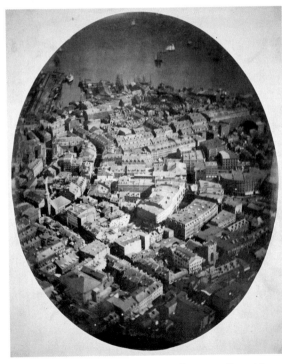

3. James Wallace Black, *Boston from a Balloon* (the "Queen of the Air"), 1860, albumen print, 9½ x 7½ in., courtesy of the Boston Public Library, Print Department

comment on the first Iraq war, in a haunting political installation of multiple images.

No overview of aerial photography has been published since Beaumont Newhall's *Airborne Camera* of 1969, and Newhall concentrated largely on the scientific and military uses of aerial photography, to the exclusion of artistic exploration.[2] In any case, almost forty years have passed since his groundbreaking publication, and airborne photography has since become a powerful political and artistic means of expression for many international artists—some working almost exclusively from the air and some adopting aerial imagery only for certain specific projects.

THEORY: BIRD'S-EYE VIEWS

Aerial photography cannot be classified as landscape photography, despite our preliminary supposition that it must be a subset of landscape representation. To understand this, one must begin with a discussion of what a landscape is—is it man-made or natural? The eminent landscape theorist John Brinkerhoff Jackson argues that landscapes are never natural; he writes that "since the beginning of history humanity has modified and scarred the environment to convey some message."[3] Even those places set aside as "forever wild" are bounded and confined by political demarcations. D. W. Meinig deepens this definition, seeing landscapes "related to, but not identical with, nature." More precisely, they are "symbolic, expressive of cultural values, social behavior," and they reveal actions on one place over time. Meinig defines landscapes as accumulations rather than pure entities.[4] Landscape photographers carry this mediated view one step further to a cultural commentary on the man-made nature of landscape. By the act of framing a specific portion of the earth through the viewfinder's rectangular frame, the photographer also creatively marks the land the camera records.

Aerial photographs differ fundamentally from conventional landscape views. The New England author Oliver Wendell Holmes wrote of this very clearly as early as the 1860s: "Boston, as the eagle and the wild goose see it, is a very different object from the same place as the solid citizen looks up at its eaves and chimneys."[5] James Wallace Black's view of Boston from 1860 makes this evident (Figure 3). Its oval shape creates a facsimile of a global view, despite the fact that Black shot this photograph from a balloon. Yet there is no horizon—intersecting streets create a new topography that edits out sky, shadow, and city-dweller to form a two-dimensional graphic composition of curved lines. In contrast, all

other landscape photographs are predicated on a human's conventional point of view, which is taken from a standing position upon the land.

This land-based viewpoint has a long history, dating back to Alberti's 1435 Renaissance treatise on one-point perspective, "On Painting." Alberti's rational theory of representation has dominated landscape imagery to this day, mandating the use of Euclidean geometry to transpose a three-dimensional space onto a two-dimensional surface, presenting the logical explanation of proportional diminution towards a vanishing point, and codifying the concept of viewing the world pictorially as if through an open window at human scale.[6] In conventional views, the horizon line and the scale of a human spectator are central characteristics that make sense of the view. Aerial views have neither. The entire experience of viewing the earth from the air is a modern phenomenon, barely two centuries old, and large numbers of people have climbed into aircraft to gain this viewpoint only in the twentieth century.

Therefore, aerial photography is transgressive in a number of ways. Where conventional landscapes are made from a human eye-level, aerial views are taken from above. Where landscape implies touching the earth, aerial imagery explicitly takes off from it. Where we are accustomed to standing in one place and seeing life move in front of us, aerial views are uncannily still, somehow frozen by their bird's-eye viewpoint. People imagined such a bird's-eye view long before they could record it, and in 1817 the early balloonist Prince Pückler-Muskau wrote:

> The earth which we had recently left lay extended in miniature relief beneath us, the majestic linden trees appeared like green furrows, the river Spree a silver thread, and the gigantic poplars of the Potsdam Allee, which is several leagues in length, threw their shadow over the immense plain.[7]

In contrast to conventional landscapes, aerial photographs contain no Renaissance one-point perspective, no horizon, no vanishing point, no human scale, and few nuances of light and shadow. There is no sky, and no topographical, architectural or human shape silhouetted against the horizon. Instead, aerial imagery is often closer to a map; it is flat and usually shadowless, revealing an endless geometric or graphic patterning. The vantage point is often dictated by the photograph's use. War photographers and technical photographers use different angles for different kinds of information: forty-five degrees for certain uses, directly vertical views for others, and dramatically slanting oblique views for yet another set of purposes.

The artists presented here are less rigid in their angled viewpoints than photographers working solely on commission, but despite their artistic freedom they use all variations of aerial views. Their photographs map the topography of the earth, not the intersection of earth and sky like conventional landscape images. When the photographers choose black and white film as their medium, dramatic graphic patterning replaces the nuances of figure and ground. When color is an essential ingredient, these photographers find brilliant vermilions, emerald greens, and turquoise patterns in the earth, and exploit them for their formal beauty or political messages. The world in this imagery is unpopulated—of all the photographs I have discovered, almost none are of a scale to allow human figuration. Thus aerial photographs present a world that is shaped by man but not visibly inhabited by humans.

These contemporary photographers experiment with these limitations—or freedoms—in a variety of exciting ways. For some, the abstraction created by the lack of a horizon affords a poetic formulation of the land. For others, the view from on high allows a moral superiority, as in environmental commentaries. For certain artists, aerial photographs capture the marks made on the earth by political events such as recent wars. Yet others show human effects on the land over time, and a few record archaeological structures from the sky.

In all cases, the photographers assume a God's-eye stance, assuming a moral superiority of some sort. This is comparable to the visual and political control exercised in Jeremy Bentham's Panopticon, as discussed by Michel Foucault, but these artists have a wide variety of uses for their powerful viewpoints, many far removed from the hegemonic power-position that Foucault describes.[8] Airplane vision is a fundamental tenet of modernity, as the modernist master architect Le Corbusier explored in his book *Aircraft*, first published in 1935. Although he did not make aerial photographs, he recognized a new kind of vision. "The eye now sees in substance what the mind could only subjectively conceive; [the view from the air] is a new function added to our senses; it is a new standard of measurement; it is the basis of a new sensation."[9]

Contemporary aerial photographs build upon the notion of a "new sensation" in a variety of ways. First, there is often humor in the imagery. In addition, the fascination with technology forms a thread that connects photography and aeronautics. Many of these artists are also pilots, and others are fascinated with the special camera technologies that aerial photographs require. Some invent the newest sorts of equipment, but others return to tried and true—or

wildly imaginative—historical processes such as kite photography or pigeon photography. The oddities of aerial photography, in fact, form a large part of its history, and it is worth following the technical developments in full.

Another issue is the adventurous nature of aerial photography itself. As the latest landscape frontier, it attracts a certain adventurous mindset. The photographers (both male and female) often pilot their own aircraft. A lingering obsession with the Machine Age, or with the wonders of the industrial revolution, seems to be a common theme for many of these photographers—they frame the land through one kind of machine while piloting or riding in another. Small-plane technology and camera technique seem to go hand in hand—Heisey builds and redesigns his own ultra-light planes and leans over his leg to shoot outside the grasshopper-like aircraft, McLean also leans out of his two-seater Cessna while steering the plane and snaps his images, Pastorino Díaz builds his kites and remotely controls the camera. Bridges, who chooses to hire pilots when she photographs, has nonetheless learned to pilot planes herself. Even non-piloting photographers such as Frank Gohlke write of the visceral experience of photographing while flying, relying only on instinct while freezing a silent image below from aerial speeds of 60 mph and above. Finally, many of these photographers use large-format cameras, increasing the technical knowledge and craftsmanship (and risk) essential to their picture-making.

TECHNICAL HISTORY

Hot-air balloons, the first manned flights, date from the 1783 flights of Joseph and Étienne Montgolfier in Annonay, France. Although their first passengers were farm animals, human passengers flew across Paris the same year. A manned balloon traversed the English Channel in 1785. Ballooning was popular by the mid-nineteenth century, and was used for military communication in the Civil War and the Franco-Prussian War. The French photographer Nadar, who first ascended in a balloon in 1857 and built an improvised photographic darkroom in the basket of his balloon, was not alone in his fascination with the new technology. His autobiography, *Quand j'étais photographe*, amusingly recounts his exploits in attempting to record a photograph in December 1858, on day two of an attempted photographic flight in the Val de Bièvre outside of Paris:

> Even though it is chilly, I take off my overcoat, which I throw on the ground, then my vest, then my shoes. . . . I unballast myself of everything that can weigh me down and finally I rise, to about 80 meters. I open and close my lens, and I

shout impatiently: "Descend!" They pull me down to the earth. With one leap I dash into the inn where, trembling, I develop my picture. . . . Good luck! There is something! . . . It is nothing but a simple glass positive, very weak because of the smoky atmosphere, stained after so many vicissitudes, but no matter! It cannot be denied: here right under me are all of the three houses in the little village: the farm, the inn and the police station. . . . You can distinguish perfectly a delivery van on the road . . . and on the roof-tiles two white pigeons who have just landed there.[10]

Nadar's obsession with ballooning did not stop there; he founded a magazine, *L'Aéronaute*, and built an enormous new balloon, *Le Géant*, with a two-story basket, a lavatory, a darkroom, and beds for twelve passengers.[11] This last balloon almost killed him in an 1863 crash, and he sold it in 1867. In 1868 Nadar made many photographs from yet another balloon, the *Hippodrome*, including the views of Paris we now know (Figure 2). These views prove that the lack of horizon, bird's-eye view, direct vertical viewpoint, and detailed information of later imagery began in the mid-nineteenth century. Nadar's aerial photography continued into the Franco-Prussian War, when he directed the balloon corps that sent messages from besieged Paris to the exiled government in Fontainebleau. His pioneering efforts were followed by unmanned balloon cameras, including Walter Bentley Woodbury's 1877 machine, weighing only twelve pounds.[12]

Although Nadar was the first to successfully photograph from a balloon, James Wallace Black made elegant images of Boston in 1860, well before Nadar's surviving Paris views. Black's balloon view, made from *The Queen of the Air*, was made while the balloon was tethered, after which the team released the balloon and Black continued to photograph while traveling across the New England countryside.[13] Black's overall view of Boston (Figure 3) is slightly more conventional than Nadar's Paris views, with a more oblique view that allows for a reduction of size in the topmost buildings and an atmospheric haze approximating sky in the top of the view. Both Nadar and Black, however, allow us to read the layout of streets and the urban fabric in a map-like way that no land-borne photograph of the time allowed.

In the decades following their pioneering efforts, photographers developed other techniques to obtain airborne views, and some of them have been readopted by contemporary photographers. By 1889, kite cameras arrived on the scene, when Arthur Batut built the first such kite—an enormous kite (a full eight feet by five feet) with a homemade box camera attached (Figure 4). Batut released his shutter either by a slow match fuse or by an electrical current on a wire attached

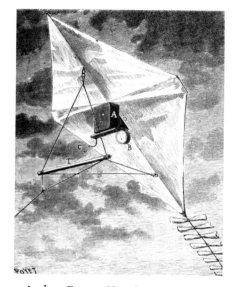

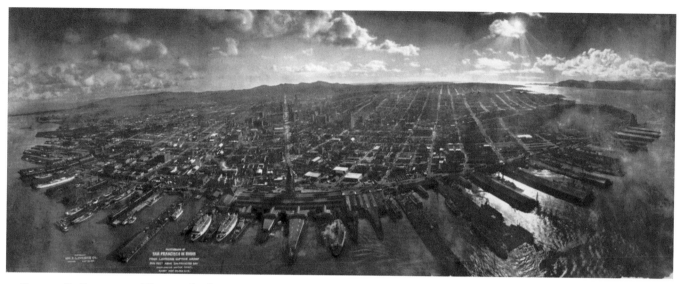

4. Arthur Batut, *Kite Camera*, 1889

5. George R. Lawrence, *Photograph of San Francisco in Ruins from Lawrence Captive Airship, 2000 Feet Above San Francisco Bay*, 1906, gelatin silver print, 18 x 48 in., courtesy of the Library of Congress

to the kite. He published a book, *La Photographie aérienne par cerf-volant*, in 1890, and suggested scientific uses that would be followed by aerial photographers for the next century. These included photographs by explorers, archaeologists, the military, and agriculture.[14]

George R. Lawrence created the most famous historical kite photographs of San Francisco soon after the earthquake and fire of 1906. He used seventeen kites suspended from a ship in San Francisco Bay to construct a comprehensive panorama of the city in all its devastation (Figure 5).[15] Unlike Nadar and Black's nearly vertical angles, Lawrence employed a more oblique view from 2000 feet up, so that the horizon line is clearly visible and streets and buildings recede backwards from the docks in the foreground to the distant hills and clouds behind the city. During these years, photographs were also made from rudimentary airborne rockets. Although kite photography seems romantic and archaic in concept, several contemporary photographers, including Esteban Pastorino Díaz, work with kites today.

The most eccentric historical airborne photographs, however, were made by homing pigeons. Jules Neubronner patented a pigeon camera in Germany in

1903 (Figure 6), and we have surviving images and postcards made by pigeons from as early as 1908. These cameras weighed two and a half ounces and were mounted like a square front-pack on each pigeon's chest. They recorded pictures automatically every thirty seconds.[16] Subjects and routes could be documented by recording the point of release and by knowing that pigeons always travel home in a straight line to their dovecotes. The essential absurdity of this practice was captured in *L'Illustration*, which wrote, "It is quite natural to see birds becoming photographers at the moment when men are beginning to become birds."[17]

With the efforts of the Wright Brothers, airplanes, in fact, first left the ground the same year Neubronner sent up his pigeons, in 1903. Aerial photographs from planes were not made until 1909, and some of their first military uses were by Army Lieutenant G. E. Kelly, who flew over San Francisco in 1911. The French formed one of the earliest military photographic services to make reconnaissance photographs in the Moroccan crisis in 1911, and a Frenchman, Louis Philippe Clerc, also published one of the first manuals for interpreting aerial photographs for military use.[18] By the end of World War I, the British had amassed six and a half million aerial reconnaissance photographs; Germans

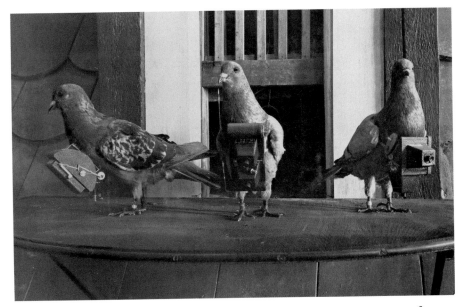

6. Dr. Julius Neubronner, *Three Pigeons With Cameras*, c. 1903, courtesy of Deutsches Museum, Munich

had been photographically mapping the terrain as well.[19] In Great Britain, the first school of aerial photography was established in Farnborough, Hampshire, during World War I, and its collection of images from that period numbers about 200,000 negatives.[20] Many of these early photographers were daredevils, and Captain Alfred Buckham, a British military photographer from World War I through the 1930s, was perhaps the wildest—a Navy aviator who crashed eleven times, and famously tied one leg to the strut of his seat while he made his airborne images.[21]

By the end of the war, Americans had collected 1.3 million aerial photographs. Edward Steichen—already a well-known artistic photographer in the Pictorialist art photography movement—worked with aerial photography in World War I, and set up the first photographic reconnaissance division in the American Signal Corps in 1917 and 1918.[22] Planes flew twice daily over the trenches, and the resulting images were laid into an overlapping mosaic to map the terrain. Other early American aerial photographers at the end of World War I included General George W. Goddard (USAF) and Captain Albert Stevens.[23]

In all four countries, manuals and instruction on interpreting aerial photographs were as important as the mechanics of making the images from the aircraft. Invaluable interpretive tools included the angle of the shot, the manner in which photographs were overlaid with other images, the sharpness of the image, the distance from the target, and the practice of rephotographing the same sites at a later time to document changes in the landscape. Most importantly, a veritable science emerged on photographic angles. Oblique views (45 degrees) had certain uses, direct vertical views (90 degrees) had other purposes, and there were many variants in between.

An early manual from 1919, Herbert E. Ives's *Airplane Photography,* offers some interesting details. He lists different kinds of images, "pinpoints," "oblique views," "mosaic views," and "stereoscopic views."[24] Ives explains the various military uses for different kinds of images, making comments such as: "Elevations and depressions of land show on an oblique view where they would be entirely missed in a vertical one."[25] He also notes that overhead pinpoint views are good for targeting artillery placement, but oblique ones are preferable to ascertain infantry information. For Ives, bird's-eye views are "most closely akin to a map," and allow the identification of "the entire form and location of buildings," whereas oblique views "possess the virtues both of pictures and of plans."[26] Another technique, mosaic maps, uses adjacent overlaid photographs to create a continuous topography. Ives also devotes an important chapter to the reading and interpretation of aerial photographs. He clarifies the importance of holding the image right-side up rather than upside down; otherwise, "reliefs will appear as hollows and hollows will show as hills. . . . The relation between the shape of the shadow and the object casting it must be well learned."[27]

Textbooks of aerial photographic interpretation veer between science and intuition. Another typical text begins, "Because photo interpretation often involves a considerable amount of subjective judgment, it is commonly referred to as an art rather than an exact science." The author continues to suggest that photogrammetric engineering is combined with deductive reasoning.[28] Complicated mathematical formulae are presented, to derive size and scale of objects on the ground.

These early military uses of photography soon led to broader scientific uses, and Ives noted the variety of possibilities early on, predicting aerial photographs for advertising, landscape gardening, engineers, surveyors, aerial photographic news services, geology, and earthquake and wave responses.[29] One early scientific

field to take advantage of aerial photography was archaeology. Kite photographs of Egypt were made as early as 1910, and *Wessex from the Air*, a seminal publication in 1928, revealed the large-scale patterns of Roman occupation in Britain.[30] Archaeologists now routinely use aerial photographs (and sometimes infrared photographs) to identify earthworks, soil marks, crop marks, parch marks (grass growing over a site), and the patterns of past town planning.[31]

In the 1930s, the popular press reproduced a number of aerial photographs. The Hungarian-born Martín Munkacsi, who made some of the most important early photojournalist images in Weimar Germany, photographed the new German flying school near Munich, opened soon after Lufthansa began operations.[32] He also traveled on the first commercial Zeppelin dirigible voyage to South America in March 1932 (Flight LZ127). Munkacsi's aerial images from that voyage, reproduced in the *Berliner Illustrierte Zeitung* the next month, include remarkable aerial views of a ship—the *Cap Arcona*—that stopped to wave at the Zeppelin, and striking close-up aerial shots of workers reaching skyward to grasp the landing lines as the dirigible landed in Pernambuco.[33]

Strategists in World War II used aerial photography even more extensively, especially with the records secured by Sidney Cotton, a British World War I veteran who took views over a large portion of Europe just before hostilities broke out. His model was followed throughout the war. Perhaps the most renowned of these photographers was the writer Antoine de Saint-Exupéry, who flew F-5 aircraft in the Mediterranean Allied Photo Reconnaissance Wing.[34] Edward Steichen returned to aerial photography for the American Navy, overseeing the collection of over fifteen thousand prints for the Naval Aviation Photographic Unit.[35] With the increased ease of air travel, less technically specialized photographers began practicing aerial photography. The most popularly acclaimed was Margaret Bourke-White, whose specially designed flight suit and bombing photographs were highlighted in a war-time *Life* magazine article.[36] Tools for reading these photographs also progressed into the eventual fields of photogrammetry and mapping the earth from satellites.

After World War II, rockets, which had been used for very early aerial photography experiments in Germany in the 1890s, reentered the photography world with the first projects of the US space program. Rocket-mounted cameras recorded the Earth as early as 1946. The satellite Explorer VI first depicted the Earth in 1950, initiating detailed study of weather patterns as well as military information. The Corona reconnaissance project—a spacecraft imaging system to photograph the Earth—began in the late 1950s, and gained fame in the early 1960s at the time of the Cuban missile crisis.

Manned spacecraft in the 1960s advanced these representations another step. The Apollo 8 spacecraft recorded Earth in color in December 1968 (Plate 48), allowing the Earth to appear as a jewel-like green-blue orb rising above the lunar horizon, and reversing our normal perceptions of the earth beneath our feet and the sky above. Aerial photography reached 240,000 miles above the Earth, yet astronaut Frank Borman reported, "Even out at the Moon, the deep blue of the Earth is the only color you can see in the Universe."[37]

The field of aerial photography has transformed itself radically in the last forty years since those first space images. NASA has further developed its space imaging programs, launching orbiting satellites to continuously photograph the land surfaces of the earth starting in 1972 (hence the term Landsat). Universities and laboratories around the world were established to utilize photographs from these satellites, for a variety of uses. Boston University, for instance, established the Center for Remote Sensing in 1986 to apply space photography to the fields of geology, geography, and archaeology, in which it is a pioneer.[38] The Center for Remote Sensing today uses satellite imagery from numerous satellites to study details of landscapes ranging from Mars views to the deserts of Kuwait and Egypt. In one, we see a view of the Nile Valley in Egypt snaking through barren desert (Plate 50). Today, commercial systems resolve ground detail down to one square meter.

COMMERCIAL AERIAL IMAGERY

Commercial aerial photographers are working prolifically today. Georg Gerster, for example, has been aerially recording archaeological ruins for four decades. Gerster, a Ph.D. in literature who has been photographing and writing for the *National Geographic* for many years, presents a scientific agenda for his photography, calling himself a "freelance journalist who specializes in science reporting and aerial photography."[39] Gerster first began making aerial photographs in 1963 while recording Nubian sites. His articles and accompanying photographs of the building of the Aswan Dam and archaeological repositioning of Abu Simbel are among his best known.[40] His most successful commercial work is a series of Swissair posters. In a recent project, *The Past from Above: Aerial Photographs of Archeological Sites*, the J. Paul Getty Museum published Gerster's decades of photographic endeavors.[41]

The most prolific commercial aerial photographer working today is Yann-Arthus Bertrand, whose many books, websites, and projects have made airborne imagery well known. Bertrand has organized a website, publications company, and professional agency, "Altitude," in support of his beliefs for sustainable development around the globe.[42] In distinction to Gerster, who concentrates on archaeological sites, Bertrand ranges wider in his aerial photographs. He calls his ongoing millennial project, "Earth from Above," a portrait of the Earth. Its support from UNESCO, Club Med, and other sources has created an archive of almost half a million images from one hundred and fifty countries.[43] Bertrand's images are beautiful compositions, but he repeatedly states that for him the message trumps aesthetics. On his website, he clarifies that for him, "meaning prevails over formal beauty, and a good photograph, with the power to challenge, instruct and move us, will always be preferred to a beautiful image."[44]

TO FLY: ART AND AERIAL PHOTOGRAPHY

In opposition to military, scientific, or commercial aerial imagery, the tradition of aerial photography that engages with the art world dates from Nadar. In the earlier part of the twentieth century, several art photographers manipulated conventional perspectival images, in a counterpart to aerial photography. Although they did not actually fly, they introduced the vocabulary of unconventional aesthetic concerns that later aerial photographers would continue to explore.

The French artist Jacques-Henri Lartigue, whose informal photographs around the turn of the century introduced the notion of play into art photography, was not a pilot, although his brother Zissou both built and flew aircraft. But his oddly disorienting photographs of jumping figures and of free-floating planes in varying flight patterns and orbits reflect a fascination with the airborne image and a departure from conventional perspectival or land-based imagery.[45] Lartigue's first published images depicted an airplane, viewed from the ground.[46] The experimental vantage points of his photographs of siblings and friends in mid-jump would not be widely repeated until mid-century—although the American painter Thomas Eakins had photographed a boy jumping as early as the 1880s. In the 1950s, another art photographer, Aaron Siskind, attempted to turn conventional perspectival representation on its head in his series "Levitations" which depicted people in mid-jump—airborne with no grounding horizon line. His contemporary, the portraitist Philippe Halsman, made a career of photographing people in midair, demanding that they jump before the camera's lens in order to separate themselves from a quotidian grounded viewpoint. All three of these photographers, however, photographed people in midair, rather than flying up themselves to obtain views of the ground from above. Not until the middle of the century did art photographers physically leave the ground to look seriously down at the Earth below them, in an attempt to transcend conventional representations.

In 1974, an artist for whom flight was a one-time experiment made an early exceptional series of aerial photographs. In his series of folding books depicting uninflected places such as the Sunset Strip, the Pop artist Edward Ruscha included one book titled *34 Parking Lots in Los Angeles*, where images were recorded from a helicopter.[47] In his collection of deliberately banal black-and-white images photographed by a commercial pilot, Ruscha presents a string of parking lots that include the Hollywood Bowl and Dodger Stadium lots. This small book pioneers the notion of serial images and an artistic interplay with repetitive aerial imagery. Decades later, photographers would return to his fascination with the abstraction created by urban patterns of land use.

SEMINAL FIGURES

In the 1950s, several seminal photographers set the stage for contemporary artistic explorations from the air. Two Americans, Bradford Washburn and William Garnett, and an Italian, Mario Giacomelli, fall into this group. Washburn is the earliest of the three, beginning aerial photography in the late 1920s; Garnett and Giacomelli began working only after World War II. All three photographed primarily in black and white, and all have passed away very recently, marking the end of a first generation of aerial art photographers.

Bradford Washburn, who died in January 2007, won his first photographic competition in 1929 and devoted his life to photography, geological research, and mountaineering. He did not define himself primarily as a photographer, writing, "I wasn't taking photographs to make art. I was using my photographs to assist me with other scientific research or projects that I was working on."[48] The founder and first director of the Boston Museum of Science (from 1939 to 1980), Washburn was both a scientist and an artist, and he began making aerial photographs in 1929 as a tool for mapping the topography of uncharted mountains. Washburn used a large-format camera throughout his career, ensuring that the quality of his luscious black-and-white photographs of the

mountains he documented was eerily detailed.[49] He is best known for his large aerial photographs of Mount McKinley, which he first made for the National Geographic Society in 1936. Washburn returned to Mount McKinley repeatedly throughout his career.

Washburn was a true pioneer of aerial photography, not only in beautiful imagery but in the mechanics of the craft, and he wrote of the improvised repairs that were often necessary on these trips. The sport of surviving the technical difficulties is evident in a shot of Washburn photographing in his airplane (Figure 7). During his career, Washburn climbed and photographed in Switzerland, Alaska, Mount Everest, and the Grand Canyon, and made more than 3000 aerial photographs of Alaskan glaciers. He often piloted his own plane, and worked from both planes and helicopters; he also designed a special ¾-inch optical glass window for the Learjet he often used. Washburn writes of the challenges and adventures of high-altitude aerial photography:

> Good pictures at high altitudes are the exception rather than the rule. Fatigue, cold and rough weather naturally contribute their share to make high altitude photography difficult. Panting and struggling for breath make it hard to take a sharp picture slower than ¹/₅₀th of a second. . . . There are not rules that can be laid down that will take the place of a whiff of good oxygen to whet the mind of a photographer at 20,000 feet.[50]

Washburn's photographs engage in a decades-long dialogue with environmental change. He photographed Alaska's glaciers in the mid-century years and returned often to record their continuous shrinkage over time. Although these are not overt political statements on environmental disasters, as are David Maisel's later photographs, for example, their serene compositions are evidence of changing patterns created because of human use even in the wildest of places.

ABSTRACT PATTERNS IN THE LAND

William Garnett, the second seminal aerial photographer in this exhibition, is also engaged with the environment, but in populated areas as well as wilderness. In distinction to Washburn, he and his Italian contemporary Mario Giacomelli created abstract patterns from the sky, forming striking black-and-white patterns from the landscapes they observed. Garnett flew across the country for the first time as an Army Signal Corps photographer during World War II and was inspired to learn to fly himself. Trained at the Art Center College of Design in Los Angeles, he worked as a commercial photographer after the war,

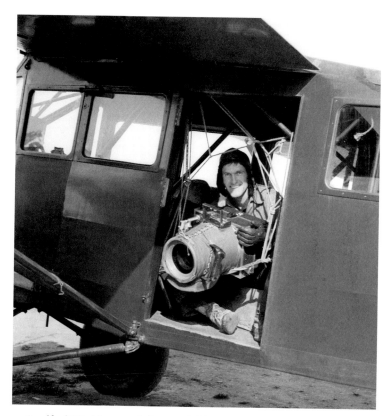

7. *Bradford Washburn and the Fairchild 71 Monoplane*, Valdez, Alaska, 1937. Photograph by Bob Reeve, courtesy of Panopticon Gallery, Boston, MA, and Bob Reeve

and illustrated Nathaniel Owing's *The American Aesthetic*, a book that served as an early inspiration for the environmental movement.[51] Garnett, who died in 2006, piloted his Cessna plane over farmland and wilderness and eventually logged almost nine thousand hours while photographing out of the window of his plane.[52] The photographer usually flew with two cameras, one loaded with black-and-white film and the other with color.[53] Garnett was one of the first photographers to make aerial photographs as artistic statements, and in 1955 Beaumont Newhall mounted a one-man show of his aerial photography at the International Museum of Photography in Rochester, New York, the first art photography show of its kind.

In an early aerial photography project, Garnett photographed a large housing development in Lakewood, California, in the various stages of its development and building in the 1950s. Garnett had mixed feelings about the topic: "I was hired commercially to illustrate the growth of that housing project. I didn't approve of what they were doing. Seventeen thousand houses with five floor plans, and they all looked alike, and there was not a tree in sight when they got through."[54] Despite the unappealing subject, Garnett's images have a symmetry and poetry that renders the uncompromising sameness of the landscape lyrical rather than grim. Aiming his camera straight down to the patterned landscapes below, he flattens the views into abstract reliefs. His penchant for finding geometric patterns and abstract beauty in the landscapes spans commercial projects, his longtime involvement in conservation and environmental issues, and artistic imagery. Martha Sandweiss, writing of his aerial imagery, emphasizes this abstraction, seeing images that "might be of a particular place, [but] they are never so much about that place as they are about the formal patterns of the land or sea as revealed by light at a particular moment."[55] Garnett's straight photographic style and homage to natural beauty place him in the company of contemporaries such as Ansel Adams and Eliot Porter. Adams cogently captures Garnett's combination of geometric abstraction and empathy for the built environment when he writes:

> Perhaps the first thought that enters the mind when observing Garnett's photographs relates to their abstract quality. I feel strongly, however, that his images are not abstract: the objective image of the lens is very real. He has in no way manipulated the basic images, but he has managed them very well at the intuitive levels. . . . I think of his photographs as "extracts"—imaginative selective fragments of the amazing world unfolding beneath him.[56]

Garnett's photographs may be abstracted "extracts" of the real world, but the aerial photographs of his Italian contemporary Mario Giacomelli are far more emotional, and exchange the particularities of the actual landscape for symbolic poetry in black and white. Giacomelli, who died in 2000, stayed quite close to home for his entire career, photographing his native Senigallia in the Marche region of Italy throughout his life. Giacomelli began photographing in 1954, and soon joined the group of young photographers around Giuseppi Cavalli, forming the Misa photographic group. Sharing with Cavalli a belief in the emotional and artistic impact of photography, he found inspiration in the landscape around his home town. He equated the rough furrows of ploughed land to the marks of age on the human body, telling an interviewer, "Look, those wrinkles, like in the face of the old, look at the wrinkles in an old person's face and you're looking at the furrows ploughed in the field. It's the same. Don't you see?"[57] Giacomelli explored these ideas in several series, *On Being Aware of Nature* and *The Metamorphosis of the Land*. In the early 1970s, he discovered aerial views when flying to Bilbao, Spain. Soon he was photographing with a friend in a crop-dusting plane, and he extended his metaphoric commentaries of the land to aerial views, which he made until the end of his life.[58]

While Garnett believed strongly in straight photography, Giacomelli manipulated his images in a variety of ways. Like Garnett, he often photographed from an almost vertical vantage point, and there is no horizon visible in his images. However, he actively manipulated his negatives—overexposing and overdeveloping his film for great contrast, scratching marks into his negatives to increase the geometric effect of his prints, and finally even carving the earth itself before he photographed it. In an effort to increase the emotional impact of his views, he asked friends to plow certain patterns in their fields, and then photographed them from the air.[59] These altered images depart from environmental commentary, although he was strongly attached to his native region and respected its long farming history. Giacomelli employed the earth as a canvas to be mauled and marked, in a rough and early parallel to Robert Smithson's earthworks several decades later. The grainy quality of these images, and their completely flat compositions, coupled with the harsh contrasts of black and white in his printing techniques, create a far harsher and more personal commentary than that of his American counterparts. Only Aaron Siskind, in his abstract close-up views of graffiti and rock formations in the 1950s, comes close to this lyricism, but Siskind's feet remained firmly planted on the ground.

Where Garnett and Giacomelli aim their cameras directly down at the ground to create abstract earthwork patterns in black and white, some photographers create airborne abstractions in the sky. If Giacomelli's roughly plowed furrows and grainy images operate at one end of a symbolic metaphor of earth and sky, Bosworth's lyrical abstractions are at the other; neither sees a practical use for the images but both are firmly imbedded in the particular details they observe. Both use aerial imagery as one small part of their larger examinations of the landscape. Barbara Bosworth uses her 8x10-inch camera to photograph clouds from commercial aircraft. Because it is unwieldy to get the large camera up to the glass window, she makes oblique views, rather than shooting directly downward

like Giacomelli or Garnett. Looking down at the cloud cover obscuring the ground, she makes ethereal skyscapes unlike those of any other photographer in this show, although they recall Georgia O'Keeffe's cloud paintings made from airplanes.

Bosworth has worked with landscape imagery from the ground throughout her career, photographing America's "champion trees," bear hunters, and a broad range of landscape subjects.[60] She studies the intersections between nature and people, and often examines the quality of light and of flight in the context of nature even when she is on the ground. For instance, Bosworth's star photographs frame the infinity of the night sky—seen through telescopes—in both black and white and color images of great subtlety. Her interest in flight is also evident in her firefly series—photographs that show fireflies both free and caught in jars—and in an ongoing series of photographs of birds being released from the hands of bird-banders. The blurred, brightly colored birds are thrown skywards from the hands of humans standing still and releasing them into flight.

Bosworth's cloud photographs have no ground in them at all; they are landscapes of the sky that have strong analogies to Alfred Stieglitz's lyrical cloud photographs—his "Songs of the Sky." (Stieglitz, too, insisted that we ignore any reference to the landscape and respond only to the abstract qualities of the cloud forms.) Bosworth does, however, create a sky-and-ground relationship in her images, and the photographs center on a "horizon" line where cloudbanks meet sky above. In the delicacy, subtlety, and balance of her prints, these images recall the seascapes of Hiroshi Sugimoto; both Bosworth and Sugimoto make serene world views out of almost nothing. One of her views frames a cloud version of an Antarctic ice floe; another suggests a desert-scape, and a third has no horizon at all, merely a continuous cloudbank seen from above, with one tiny airplane in the lower right corner that grounds us and simultaneously dismantles our notion of scale. As she looks down at the sky, Bosworth calls these images an exploration of the relationship "between heaven and earth," photographing not only the sky and ground, but their metaphorical meanings as well.[61]

ENVIRONMENTAL ELEGANCE

Bosworth studies the transcendental beauty of natural gentle cloud formations, from above and also from the ground, looking up. Frank Gohlke, however, studies the effects of a far less benign cloud—the volcanic ash eruption of

Mount St. Helens in Washington in May 1980. Like Bosworth, he turned to aerial photography as one tool in his formal vocabulary, for this project only. In 1981, and again in 1982, 1983, 1984, and 1990, he traveled repeatedly to the site of the volcano's eruption, photographing not only the cataclysmic effects of the original blast but the slow regeneration over the next decade. During these trips, he sometimes flew over the mountain and sometimes hiked it, recording the loss of its conical peak and the rebuilding of a new, smaller lava cone within the hollow. Gohlke also ranged many miles outside the blast zone.

Of all the photographers in this group, Gohlke is the one normally most wedded to the horizon line because of his iconic, decades-long photographic images of the Midwest, with its vast horizon, big sky, and flat spaces. Gohlke's photographic style, a kind of plain vision, developed among the group of photographers celebrated in the 1975 exhibition *New Topographics: Photographs of a Man-altered Landscape.*[62] Although the Mount St. Helens project ranges far from "man-altered landscapes," Gohlke's work continues to reflect the idea that photography's "neutrality lies in the way the edges of the picture function and [the] work maintains an essentially *passive* frame."[63] His aerial views of Mount St. Helens depart radically from his normal vision, although he also used his plane trips in order to decide where to go on the ground.[64] These images were made through the open window of a two- or four-seater Cessna and occasionally from a helicopter, and the photographer asked the pilot to bank the plane so he could shoot out the open window. Gohlke remembers the speed with which he was required to work: "You're going entirely on instinct . . . shoot, shoot, shoot, shoot," and that the result is always a surprise. "You're completely improvising the whole time you're up there."[65]

These images are a poetic commentary on nature's violence, and also on the rebuilding that occurs over time. Frank Gohlke has always been a thoughtful verbal as well as photographic commentator on the idea of landscape photography. He writes:

> There must be an Other before there can be love; Eden becomes the object of our desire only after we are cast out. The best landscape images . . . are predicated on that loss. . . . In the case of landscape photographs, the paradox is sharpened because the world represented must have existed for the picture to be made, and yet the existence of the photograph attests undeniably to that world's disappearance.[66]

In the case of Mount St. Helens, the loss was violent and immediate. On May 18, 1980, the mountain literally blew its top, hurled itself "about a quarter of a cubic

mile over the landscape, devastated 250 square miles of the surrounding land, and killed sixty-one people."[67] The Plinian column of ash rose 65,000 feet into the air and lasted for nine hours.[68]

In his trips to Mount St. Helens Gohlke records the changes of landscape over time. He does not ignore the cataclysmic side of this landscape, noting that "Mt. St. Helens is the only place on the continent where one can *see* so clearly the effects of forces comparable in scale to those produced by nuclear weapons." But he marvels that "it has not led to terror or despair, because nature's powers of generation and regeneration are everywhere in evidence and every bit as awesome as its powers of destruction. In ways I cannot entirely account for, it has strengthened my own capacity for hope."[69] Over a decade, Gohlke's photographs celebrate the complex, intermingled patterns of destruction and regrowth visible in this dramatic landscape.

Gohlke's friend Emmet Gowin, however, employs a more consciously sublime style than his colleague, and comments more overtly on man-made environmental and pollution issues in the landscape. Gowin, too, began making aerial photographs of Mount St. Helens in 1980,[70] but a 1986 side trip over the Hanford Reservation (home of the Manhattan Project) soon redirected his thoughts to the scars that humans make on the land. Gowin's trip over the nuclear-test-ravaged reservation transformed his photographic vision. "What I saw, imagined, and now know, was that a landscape had been created that could never be saved. I began in the next year to search for the other signs of our 'nuclear age' missile silos, production sites, waste treatment and disposal sites."[71] Since the 1980s, Gowin has been making aerial photographs of pollution in the Czech Republic, Mexico, the Middle East, Japan, and the United States. The aerial images included here expose the impact on the land by pivot irrigation and by other forms of pollution.

Where Gohlke strives for a passive frame, Gowin consciously tones his images to increase their graphic and emotional impact. Gowin was strongly influenced by Frederick Sommer and followed Sommer's use of strong light and print bleaching to increase his effects. Gowin intentionally uses metallic tints when hand-toning his black-and-white photographs, to "produce a distinct sensation of toxicity and alarm."[72] The toned prints, paired with the strong, often beautiful formal patterns he finds in the scarred earth, leave an emotional mark. For instance, Gowin's pivot irrigation images, graphically circular in form, are both elegant—like Giacomelli's patterns in the earth—and eerily indicative of misuse,

because of the vast waste of underground aquifer supplies made by the method of mechanical irrigation.

The strong geometric patterns Gowin frames from his chartered plane reveal human marks on the skin of the earth in several ways: they impose geometry on the terrain, they show our misuse of the land, and they mourn in a poetic language. He believes photographs should make an emotional impact, writing, "This is the gift of a landscape photograph, that the heart finds a place to stand."[73] He presents himself as an "artist/citizen," and, as museum director Jock Reynolds writes, he searches both for beauty, and to bear "witness to hard truths through his art making."[74]

David Maisel also concentrates on polluted spaces and frames them as abstract patterns from the sky. Maisel first discovered aerial photography in 1983, accompanying his teacher Gowin on one of his Mount St. Helens flights.[75] Maisel's aerial photographs in luscious color share Gowin's sensuous detail to make their environmental arguments, but he employs a much stronger graphic abstraction and uses far grander scale in his work. Maisel has no need to hand-tone his images; he finds lurid colors in the polluted sites themselves.

Unlike some of the other photographers who alternate between air and ground shots, most of Maisel's work is aerial. He photographs from low-flying aircraft, and uses sharply banked turns to aim his camera vertically at the ground. These close-up, luridly colored, and strongly patterned images have no human orientations—unlike oblique aerial views that still recall an up and a down. Maisel describes his disorienting vision himself:

> Rising above the site, we became a disembodied eye. With camera lens trained on the dead lake, its skin was peeled back, the exquisite corpse revealed. A river of blood, a split-tongued vein, a hundred acres dried like a scab, pigmented dust mottled, a galaxy's map splayed out below us.[76]

In another passage, he senses an interaction between the lakebed and the camera's eye, witnessed from his plane seat. "We can almost give in to the languor of the engine's drone; the motor drive of the camera winds more slowly, the focal shutter closing its blackness on the scene like a heavy lid. The camera blinks, the lake blinks back, and we are gone."[77] Maisel views the scarred earth as a damaged body and his camera as the surgeon's eye; both landscape and photographer share a symbiotic physicality.

Instead of identifiable places, therefore, the polluted landscapes become color field patterns of geometric or sinuous colors and lines, with an edge that

combines great beauty and unease—what Robert Sobieszek calls "ambiguous new geographies of the psyche, primordial backdrops to violence and desolation."[78] Maisel, like Gowin, equates the polluted face of the earth with a scarred beauty, this one terrible in its beautiful color.

The projects themselves address environmentally challenged places. The *Lake Project*, a series of images of Owens Lake, records a dried-out lakebed drained to supply water for Southern California since 1913. Another project, *Terminal Mirage*, studies the Great Salt Lake, the subject of another of his mentors, earthworks artist Robert Smithson. In Owens Lake, the remaining silt teems with mineral deposits, many of which are carcinogenic: nickel, cadmium, arsenic. (He notes that thirty tons of arsenic and nine tons of poisonous cadmium were being emitted each year.)[79] In photographing these places Maisel concentrates on the lurid red-orange tones of bacteria blooms and arsenic-poisoned waters, as well as the greens, yellows, and other violent shades of bacterial pollution. The luscious reds, for instance, depict salt-loving bacteria called halobacteria.[80] By hovering above this lakebed and geometrically framing his colored pollution as a series of stunning patterns, Maisel poses a problem: "The conundrum is thus: demise of the lake = dizzying, imperial beauty."[81]

PLANNED LINES IN THE LAND

Not all aerial photographers concentrate on abstraction or environmental issues. Many study the subtleties of the interactions of usable space, and aerial photography's freedom from pictorial convention is a powerful tool. Terry Evans has been photographing the Midwest from the air since the early 1990s. Earlier, Evans recorded the patterns of native Midwest prairie land from a directly overhead view. This translated naturally to a vertical kind of aerial view comparable to Maisel's and to a similar interest in environmental issues, which she published in 1998 as *The Inhabited Prairie*.[82] Where Maisel is fascinated by pollution, Evans is more interested in the interactive issues surrounding conservation. She works in early morning and late afternoon, so that the raking light will show the subtleties of the prairie flatness most clearly.

After she moved to Chicago, Evans first photographed the Joliet Army Arsenal south of Chicago—a site that had once housed the world's largest TNT factory, and that became the Midewin National Tallgrass Prairie in 1997.[83] Soon afterward she was approached by the Openlands Project and by Chicago Metropolis 2020 to create an aerial survey of the city titled *Revealing Chicago*. The organizers who commissioned Evans for this project valued her artistic vision as well as her conservation values.[84] During forty-five flights, she photographed the Chicago region from helicopters, a Piper Cub plane, and even a hot-air balloon, and planned a systematic look at Chicago that began and ended with the lake.[85] The helicopter, in particular, allowed her to photograph from as low as four hundred feet, and to include people in her compositions, and some of her most successful images happened on the way to other sites.[86] The project had an enormous public presence, and was exhibited outdoors in the summer of 2005 at Chicago's Millennium Park—on one hundred 32-inch-square aluminum sheets.

Evans is particularly interested in the borders between spaces of different uses. Rather than making specific environmental or public planning images, she created an aerial metaphor for the complexity of metropolitan Chicago, a creative map.

> The lake is kind of an organizing principle and a release for the city. As soon as I realized that, I knew how to organize the book. The book starts and ends with the lake. The lake frames the city in that way.[87]

Evans is certainly not the first to organize urban imagery from the air; Ed Ruscha had done that in his parking lots project in the 1960s. Instead of Ruscha's bland, tongue-in-cheek overview of pavement, however, Evans explores the intersections of land and water, and of figures and the marks they make in the landscape. Some of her lakefront photographs frame dune buggy marks and human silhouettes on Oak Street Beach, and around the newly built, ship-shaped beach house on North Avenue Beach (the beach serves over six million people a year). Others show the graphic lines separating water from land, and the man-made barriers between the two. Her clearly colored images strive for legibility; these are sites to be recognized through their compositions, not generalized into abstractions.

Alex MacLean, working out of the East Coast, is similarly interested in the borders between areas of different land use, but he has a broader range of subjects. Although he has been making aerial photographs for almost thirty years, MacLean was trained as an architect. This interest in land-use patterns is evident in his work. He is fascinated, however, with the graphic patterns he finds in the landscape, in his home in Massachusetts and around the country. Simultaneously piloting his own Cessna 182 plane with one hand and photographing with a 35-millimeter camera out of the window with the other, MacLean concentrates on

views from one to two thousand feet up.[88] He is repeatedly drawn to geometric patterns, and to the "tensions between nature and human activity."[89]

MacLean's training as an architect informs his interest in the American grid patterns in the landscape. He refers back to Thomas Jefferson's 1785 Land Ordinance that first created a grid system, and studies its changes over time across the nation. He is also influenced by the landscape theory writings of John Brinckerhoff Jackson and by Jackson's cultural studies of American vernacular landscape. MacLean uses his aerial imagery to work on urban- and land-planning projects as well as artistic photography.[90] Photographing at vertical, oblique, and horizontal angles, MacLean isolates brightly colored fragments of landscape borders between urban, suburban, and rural spaces, what author and environmentalist Bill McKibben calls "a middle kingdom . . . enough of a community or a region to demonstrate how humanity interacts with biology, how settlement and agriculture interact with geology."[91]

MacLean's patterns are graphically striking; he seeks out geometries in the landscape rather than the subtler irregularities of Evans's views. Whether they are the curved diagonals of dry-land-farming patterns in Montana, the vertical grid of houses in Somerville, Massachusetts, or the radial patterns of a Minneapolis railroad turntable, these photographs impose a rational order from above. The photographs reconstruct a reference to Jefferson's grid in each landscape detail they capture. They often demonstrate the contrasts between history and the present, as well as between industry and nature, and the fact that all landscape is cultural geography (J. B. Jackson's views).

ARCHAEOLOGICAL IMAGING

MacLean's photographs might be read as a kind of contemporary archaeology, mapping the land-use patterns of American cities and landscapes. Several aerial photographers, however, concentrate entirely on archaeology in their work. Although the National Geographic Society photographs by Georg Gerster are widely known by practicing archaeologists, the most dramatic art photographer of archaeological sites is Marilyn Bridges, who has been flying over the great historical sites of Europe, Egypt, and Latin America since 1976. Her haunting black-and-white photographs capture the mystery of Peru's Nazca lines, Maya temples in the Yucatan, Native American monuments, and ancient Greek, British, and Egyptian civilizations.

Bridges photographs from an unusually low height, and at a speed near to stalling speed. She is a pilot herself, but chooses to have someone else fly when she is photographing so she can lean out the open doors of the small Cessna planes she prefers. Bridges revels in the danger of photographing at such slow speeds, and the act of leaning out to photograph (in Machu Picchu, she "lay flat and hung out of the door while an archaeologist held her ankles.")[92]

Bridges equates the experience of aerial photography to Henri Cartier Bresson's notion of "the decisive moment."

> I have to be very fast and completely conscious or it's gone. I don't have much time to compose, so I must be in the moment. I have to freeze what I see with emotion, so that it is more than a document. These photographs are translations of my feelings experiencing the landscape and the messages of man that remain.[93]

The low altitude and slow speed, coupled with the early and late times of day that she chooses to make her images, allow her to capture a three-dimensional quality that is rare in aerial photography. Military manuals have noted for decades the importance of shadows in reading meaning in aerial photographs, but, in photographing when the sun is low in the sky, Bridges vastly exaggerates the effects of these shadows. In addition to adding three-dimensional depth to the monuments she hovers above, these black shapes mirror but distort the monuments themselves. They become emotionally laden graphic counterparts to the stones and land, suggesting the human life and history of the buildings themselves. In her words, "shadows lift objects from the ground and . . . intimacy is regained."[94]

Bridges has a mystical connection with her historical sites, and her photographs imbue them with a life beyond that of mute stones. Her early work from 1976 documents the Peruvian Nazca lines (200 B.C. to around A.D. 600). Leaning out the open doorway, held in only by two seat belts, she thought, "I'm really seeing a miracle here. I knew they were made for a higher purpose, whatever that was."[95] She finds similar echoes in Native American monuments such as the serpent mound in Ohio or earthworks near Blythe, California. Bridges has lovingly documented the ancient monuments of Greece, Egypt, and, most recently, Anatolia. Her Egyptian images, included here, date from a first trip to Egypt in 1984. She made photographs of the pyramids in 1992 and again in 1993, negotiating with military pilots and political authorities to make some of her most mystical photographs. She recalls, "As the plane rattled its way over the Nile, the sights below were glorious. The pyramids seemed symbiotic with the sand."[96] A second journey to Abu Simbel revealed the majesty of the Valley of

the Kings. "Monuments are meant to be testimonies to permanence. Yet, ruins show us the nature of impermanence."[97]

If Marilyn Bridges is attracted to spiritualism in archaeological spaces all over the globe, a younger photographer, Adriel Heisey, concentrates on one region, making luminous color images of the area around the Navajo Nation in the American Southwest. Heisey spent twelve years with the Navajo air transportation department, during which he learned an enormous amount about its history and culture. Determined to work primarily as an aerial photographer, Heisey then designed and built his own lightweight plane, a Kolb Twinstar that weighs only 450 pounds, and is small enough to fold into a trailer for transport to any site where he can find a dirt road for a runway. Heisey flies as slow as forty miles an hour, and as low as one hundred feet above the ground, although he will fly briefly as high as fifteen thousand feet if necessary for an image. He works with his flight-control stick strapped to his leg so he can have both his hands free for his camera (Figure 8).

> Everything about the plane seemed perfect for how I wanted to use it. . . . Best of all, it was open and slow. The seat itself was the cockpit, with nothing in front of me but my own feet. If I wanted to take a picture straight down, I simply leaned out past my left thigh. The craft puttered along at 35 to 40 mph if I wanted to shoot, and at 60 if I needed to travel.[98]

Heisey photographs the Four Corners region and the sand dunes of the west and the Sonoran Desert.[99] In his photographs of sacred Navajo lands, Heisey shares the Navajo belief that "their entire landscape—not just certain places—is sacred."[100] As the Director of the Center for Desert Archeology, William Doelle, has noted, common formal themes are present: ritual, desert gravel, water patterns, context, and roads.[101] And Heisey is interested not only in past history, but in the intersection of ancient cultures and our contemporary times. For instance, a photograph of Puyé on the Santa Clara Reservation reveals the walls of many ancient rooms, highlighted by the recent snowfall. A perfect arc of footprints in the snow, however, creates an alternating pattern of "a brief, recent visit."[102] Heisey also uses the flexibility of his plane to visit many remote sites that have not been reconstructed or stabilized, so that we see the interaction of ancient sites and their changes after centuries of disuse. Respectful of the fragility of the sites, he is careful to keep their specific locations largely to himself, safely isolated in his private photo logs so his photographs will not contribute to visitor traffic that might destroy the fragile Pueblo archaeological remains.[103]

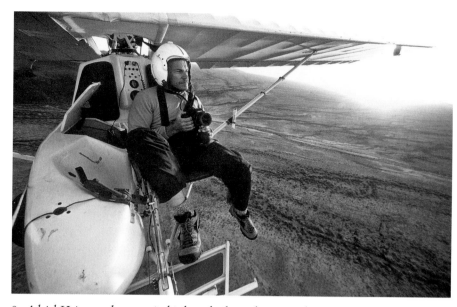

8. *Adriel Heisey and camera in his homebuilt airplane over the Sonoran Desert at Sunrise*, n.d., courtesy of the artist

Heisey has made photographs of pure landscape, but recently he has become increasingly involved with area archaeologists, particularly the Center for Desert Archaeology. He has found a way for his plane to become a tool of archaeology and to teach people about their heritage.

> The basic elements of photography—choice of moment, point of view, quality of light, composition—could temporarily brush aside the heavy overburden of modernity and let a former way of life have a moment of regard. From the ground these places are often hidden by fences, trenches, or remoteness. From the air they become part of where we live, less easily forgotten, ignored, or mistreated.[104]

Flying his small craft slowly above the western landscape, Heisey uses his aerial imagery both to increase respect for the cultural remains he finds and to honor the landscape itself.

WAR

Bridges and Heisey pay respectful tribute to past civilizations, but war photographs reveal the transformation of our own times into horrific archaeological sites. Although the vast majority of her work is not aerial photography, the

French artist Sophie Ristelhueber made photographs of the first Iraq War that are among the most chilling aerial images made in the last two decades. Ristelhueber has a long record of using battlefield imagery as her inspiration. She traveled to Beirut in 1982 to document its destruction, and has been obsessed with the signs of war in many of her installation pieces. She operates as a kind of archaeologist, stating:

> I have these obsessions that I do not completely understand, with the deep mark, with the ruptured surface, with scars and traces, traces that human beings are leaving on the earth. It is not a comment on the environment . . . it is metaphysical. . . . In a way, I am an artist standing a little like an archaeologist.[105]

Ristelhueber used aerial images as one type of image in her 1992 installation project, *FAIT*. *FAIT* recorded the detritus of war in a formal grid of seventy-one photographs mounted together on a gallery wall. For most of *FAIT*, Ristelhueber used color film, allowing the natural monochrome of the desert sand to limit her palette, though she adopted black and white when "the smoke from the burning oil field made everything appear to be shades of gray."[106] In these images, Ristelhueber is deliberately seeking the impression of being "fifty centimeters from my subject, like in an operating theater. I was so sure about what I wanted to do."[107] Eerie close-up views of personal belongings strewn on the earth alternate with derailed trains seen from the air, and the resulting patchwork is a tragic map of a destroyed society. The patterns of bombed villages resemble Heisey's centuries-old Pueblo ruins, but instead of celebrating the passage of time and culture, Ristelhueber mourns the violence of contemporary war.

Ristelhueber uses her occasional aerial images with stunning force. With a deliberate denial of conventional landscape tropes, she denies the existence of a horizon altogether, and aims at a ninety-degree angle directly down onto the earth. The effect is to disorient us as to scale, and to render train cars, shoes, and small rocks with the same obsessive detail. The result is a sand-colored, gridded map of patterned fragments of Iraq. Ristelhueber deliberately creates an absence of proportion, so that *FAIT* is both general and discreet. It allows no vacillating response, however, as to the horrific effects of war.

TO PLAY: AERIAL DISTORTIONS

Two final aerial imagemakers make playful aerial photographs that comment on history and on the history of aerial depictions in a more lighthearted and deliberately postmodern manner. Olivo Barbieri and Esteban Pastorino Díaz both make images that transform the landscape into childlike models. Italian-born Barbieri has been making a series of photographs titled *site specific* since 2003, when he began photographing Rome from a helicopter, using a perspective-correcting camera normally reserved for architectural photography. His study of Rome soon extended to other cities, and there are now *site specific* projects in Montreal, Amman, Los Angeles, Las Vegas, and Shanghai—where Barbieri has been traveling repeatedly since 1989. Each trip involves an extensive study of the specific city, a carefully planned route, an aerial film of the city, and the shooting of multiple images during two three-hour trips for each city. He then edits the images down to ten to fifteen images for each city.

Barbieri focuses sharply on the central subject of each shot, and allows the peripheral areas to blur, creating a dreamlike image with only one sharp central area. The oblique angle of the view and the shifting focus create a model-like effect, so that the Roman Colosseum or Moshe Safdie's Habitat for Montreal's Expo 1967 or the Las Vegas Luxor Casino all appear as miniaturized toys, built from Lego blocks or a kit. The variably focused compositions camouflage their gritty urban settings.

Barbieri is completely involved in the topic of cities and attempts to conceptualize them from a new viewpoint. He sees the world "as a temporary site-specific installation, structures and infrastructures, the foundation of our sense of belonging and our identity, seen from afar, as a great scale model: the city as an avatar of itself."[108] Las Vegas is a particularly apt example of the city as a scale model of itself, since the massive casinos are themselves imitations of other architectural forms. Barbieri is vividly aware of the architects Robert Venturi, Denise Scott Brown, and Steven Izenour and their iconic book *Learning from Las Vegas*, with its celebration of the temporary and the imitation; in fact, he titles his Las Vegas publication *site specific _ LAS VEGAS 05: Learning from Las Vegas, again?*[109] In the book, he cites the architects' comparison of Rome to Las Vegas: "Each city vividly superimposes elements of a supranational scale on the local fabric: churches in the religious capital, casinos and their signs in the entertainment capital. These cause violent juxtapositions of use and scale in both cities."[110]

Barbieri is intensely self-conscious about his method, and deliberately sets out to contradict the monocular, power-hungry eye of the camera. He explains, "This capacity for bias in the medium, that by definition is panoptic and decides itself on the internal hierarchical relationship of the image, had finally irritated

me. I put in effect a method which allows me to choose what I would like in focus."[111] He also playfully reorients our notion of the monumental, in images of the Luxor casino with its black glass pyramid rising above the palm trees that surround a newly rendered sphinx, or a view of the Venetian casino surrounded by its artificial canals with highway traffic clogging the foreground.

The Argentinean photographer Esteban Pastorino Díaz, on the other hand, not only blurs the image around the edges like Barbieri, but also plays games with the act of photography itself. In a deliberate return to Arthur Batut's turn-of-the-century kite photography, Pastorino Díaz has built a special camera that he suspends from a kite; he plays with the element of chance since he does not know exactly what the camera will record. Unlike George Lawrence's celebrated image of San Francisco after the 1906 earthquake and fire, Pastorino Díaz's photographs record the everyday—Buenos Aires, Greek villages, suburbs. Trained as an engineer, Pastorino Díaz began making aerial photographs from a kite. (He also makes night photographs, and developed a panoramic camera that mounts on a car driver's window.)[112] In 2003, he photographed Buenos Aires in aerial images that make the Barrio Magdalena look like red toy Monopoly houses. The short depth of field of these photographs concentrates attention on the only areas in focus, the buildings in the center of the print.

Pastorino Díaz also worked on his aerial kite photographs during a 2002 artist's residency in the Centre of Photography in Skopelos, where he photographed the waterfront, the rows of beach umbrellas, and the local construction sites. He is fascinated with the elements of chance in photography, although his engineer's precision precludes a totally random composition. He simultaneously works with and against the supposed objectivity of the camera, creating elaborate techniques to erase his author's hand. His large-format camera—handmade of lightweight foamcore board—is mounted on a Japanese Rokkaku kite, and is operated by radio control. Pastorino Díaz cannot see his image while the shutter is being released, so there is an element of chance, but the relatively short leash of the kite string allows for a measure of control. He explains that he has intentionally combined two technical effects:

> One was the short depth of field and the other is the high point of view. These two effects together would create a scale model look. I consider that the high point of view is a key part of it since, normally, we perceive the scale model from above and not from the eye level of a figure.[113]

Both Pastorino Díaz and Barbieri reduce the perceived world to a playful series of model-like forms, and use aerial viewpoints and variable focus to remove their subjects from what they perceive as the tyranny of the mechanical photographic eye.

Their fascination with the basic elements of aerial photography—a bird's-eye view, a distancing from land-bound vision, and a freedom to create a new kind of landscape—is more playful than the war-ravaged landscapes of Ristelhueber, the archaeological memories of Bridges and Heisey, the land-planning concerns of Evans and MacLean, or the environmental activism of Gowin and Maisel. Yet for all their different political and formal uses of aerial photography, these photographers all lift off from the earth—in kites, helicopters, ultra-light planes, small aircraft, and commercial jets—to find a new vision of the land, one unfettered by what we might call the human scale of vision. Whether they are eyeing the ground vertically, obliquely, or at a nearly horizontal angle, they are fascinated with a newly liberating kind of vision. That vision is partly free, yet it is also partly controlled by modern technologies. Contemporary aerial photographers share our current fascination with Google Earth and its ability to show us our own houses and streets to see how they look from above. Satellite mapping has entered our everyday lexicon, but we may not know how to interpret what we are seeing. These fourteen photographers, in their artistic explorations of aerial photography, are explaining the new language to us.

1. Nadar (Gaspard Félix Tournachon). For a detailed discussion of Nadar's balloon exploits, see Beaumont Newhall, *Airborne Camera: The World from the Air and Outer Space* (New York: Hastings House, 1969), 27, 31–35.

2. Newhall, *Airborne Camera*.

3. John Brinckerhoff Jackson, "Preface," *A Sense of PLACE, a Sense of TIME* (New Haven: Yale University Press, 1994), vii.

4. D.W. Meinig, "Introduction," *The Interpretation of Ordinary Landscapes: Geographical Essays* (New York: Oxford University Press, 1979), 2–4.

5. Oliver Wendell Holmes, "Doings of the Sunbeam," *Atlantic Monthly* (12:12, 1863).

6. John White, *The Birth and Rebirth of Pictorial Space* (London: Faber and Faber, 1957), 121–122.

7. Cited in Newhall, *Airborne Camera*, 11.

8. Michel Foucault, "Panopticism," *Discipline and Punish: The Birth of the Prison*, trans. Alan Sheridan (New York: Vintage Books, 1975), 200–228.

9. Le Corbusier, *Aircraft: The New Vision* (1935; reprint, New York: Universe, 1988), 96.

10. Nadar, *Quand j'étais photographe*, cited in Newhall, *Airborne Camera*, 21.

11. Newhall, *Airborne Camera*, 31.

12. Ibid., 34.

13. For detailed information on Black, see Sally Pierce, *Whipple and Black: Commercial Photographers in Boston* (Boston: Boston Athenaeum, distributed by Northeastern University Press, c. 1987).

14. Newhall, *Airborne Camera*, 42.

15. Ibid., 43.

16. Ibid., 48.

17. Ibid., 48.

18. Ibid., 51.

19. Ibid., 55.

20. Thanks are due to Hillary Roberts, photography curator of the Imperial War Museum, for details on these archives.

21. Thanks are due to Sarah Stevenson, Curator, National Gallery of Scotland, for information about Captain Buckham.

22. Christopher Phillips, *Steichen at War* (New York: Abrams, 1981), 11.

23. For a good memoir, see Brigadier General George W. Goddard, USAF (Ret.), *Overview: A Life-Long Adventure in Aerial Photography* (Garden City, NY: Doubleday, 1969).

24. Herbert E. Ives, *Airplane Photography* (Philadelphia: J. B. Lippincott Company, 1920), 39.

25. Ibid., 320.

26. Ibid., 330, 388–389.

27. Ibid., 386.

28. Thomas Eugene Avery, *Interpretation of Aerial Photographs* (Minneapolis: Burgess Publishing Company, 1977), third edition, 21.

29. Ives, *Airplane Photography*, 392.

30. O.G.S. Crawford and Alexander Keiller, *Wessex from the Air* (Oxford: The Clarendon Press, 1928).

31. For an overview of archaeological photography, particularly in Britain, see Mick Aston, *Interpreting the Landscape from the Air* (Gloucestershire; Charleston, SC: Tempus, 2002).

32. Martín Munkacsi, *Berliner Illustrierte Zeitung* 49 (2 December 1928). This was his first formal commission for the paper. For a fuller discussion of Munkacsi's aerial photographs, see Klaus Honnef, "Photographic Heights: The Berlin Years 1928–1934," in F. C. Gundlach, ed., *Martín Munkacsi* (Göttingen: Steidl/International Center of Photography, 2006).

33. Martín Munkacsi, *Berliner Illustrierte Zeitung* (30 April 1932): cover, 520–523.

34. Newhall, *Airborne Camera*, 60. The F-5 was a Lockheed P-38 plane modified for photographic reconnaissance.

35. Christopher Phillips, *Steichen at War* (New York: Abrams, 1981), 8, 22–25. Key photographers in Steichen's Naval Aviation unit included Wayne Miller, Horace Bristol, Charles Fenno Jacobs, Charles Kerlee, Victor Jorgenson, and Dwight Long. They concentrated more on depicting sailors' lives than on strict aerial views for reconnaissance; the project culminated in the Museum of Modern Art exhibition "Power in the Pacific."

36. "*Life's* Bourke White Goes Bombing," *Life* vol. 14, no. 9 (March 1, 1943): 17.

37. Newhall, *Airborne Camera*, 122.

38. Many thanks are due to Dr. Farouk El-Baz, Director of Boston University's Center for Remote Sensing, for his contributions of time and information for this project.

39. http://www.georggerster.com. Thanks are due to Ginger Elliott Smith for research and preliminary writings on Georg Gerster's archaeological photographs.

40. Georg Gerster and Charlotte Trumpler, editors. *National Geographic*. "Threatened Treasures of the Nile" (October 1963): 587–621; and Georg Gerster, *National Geographic*, "Abu Simbel's Ancient Temples Reborn" (May 1969): 724–744.

41. Georg Gerster, *The Past From Above: Aerial Photographs of Archaeological Sites* (Los Angeles: The J. Paul Getty Museum, 2005), 7.

42. http://www.yannarthus-bertrand.org

43. Yann Arthus-Bertrand, *Earth From Above* (New York: Abrams, 2005).

44. http://www.yannarthus-bertrand.org

45. For a complete discussion of Lartigue's work, see Kevin D. Moore, *Jacques Henri Lartigue: The Invention of an Artist* (Princeton: Princeton University Press, 2004).

46. Frontispiece, *La Vie au grand air* (24 January 1912), in Moore, *Jacques Henri Lartigue*, 71.

47. Ed Ruscha, *Thirtyfour Parking Lots in Los Angeles* (unpaginated artist's book with 34 illustrations, 1974).

48. Bradford Washburn and Antony Decaneas, *Bradford Washburn: Mountain Photography* (Seattle, WA: Mountaineers, 1999), 23–24.

49. Washburn used an Ica Trix 4x6-inch camera from 1929 to 1942, then moved in 1934 to a 5x7-inch Fairchild F-8 camera, and then to an 8x10-inch Fairchild K-6 and K3B aerial camera.

50. Mark Sandrof, "Focused," *View Camera Magazine* (September 1998), 2.

51. Nathaniel Alexander Owings, *The American Aesthetic* (New York: Harper and Row), 1969. Owings was a founding partner of the architectural firm Skidmore, Owings, and Merrill.

52. Mike Stensvold, "William Garnett Aerial Photographs," *Peterson's Photographic* vol. 24, no. 6 (October 1995): 32 ff.

53. For an overview of Garnett's aerial photographs, see Martha Sandweiss, *William Garnett Aerial Photographs* (Berkeley, CA: University of California Press, 1994).

54. J. Paul Getty Museum. Art, *Explore Art at Home* [online] Artists: Garnett. <http://www.getty.edu/art/gettyguide/artMakerDetails?maker=1580>

55. Sandweiss, *William Garnett Aerial Photographs*, viii.

56. Ansel Adams, "Introduction" to William Garnett, *The Extraordinary Landscape: Aerial Photographs of America* (Boston: New York Graphic Society, 1982), ix.

57. Mario Giacomelli, quoted in Alistair Crawford, "For Mario Giacomelli," *Mario Giacomelli* (London: Phaidon, 2001), 18.

58. Giacomelli used a homemade box camera, and leaned out of the front passenger seat of the plane to make his images. Some images were made with a 6x9 Kobbell and a 6x8.5 Voigtlander.

59. Alistair Crawford, *Mario Giacomelli, a Retrospective 1955–1983* (Cardiff: ffotogallery, 1983), 13.

60. Barbara Bosworth, *Trees: National Champions.* Essays by John Stilgoe and Doug Nickel (Cambridge, MA and London: MIT Press, 2005).

61. Barbara Bosworth, interview with the author, 19 January 2007.

62. *New Topographics: Photographs of a Man-altered Landscape.* Introduction by William Jenkins (Rochester: International Museum of Photography, 1975).

63. William Jenkins, "Introduction," *New Topographics*, 5.

64. Frank Gohlke, interview with the author, 9 February 2007.

65. Ibid.

66. Frank Gohlke, "Thoughts on Landscape," *Landscape Journal* (Spring 1995): 2.

67. Kerry Sieh and Simon LeVay, "Blasts from the Past: Mount St. Helens and Her Sleeping Sisters," *Mount St. Helens: Photographs by Frank Gohlke* (New York: Museum of Modern Art, 2005), 16.

68. Sieh and LeVay, "Blasts from the Past," *Mount St. Helens: Photographs by Frank Gohlke*, 19.

69. Frank Gohlke, "A Volatile Core," *Aperture* (Spring 1985): 29.

70. A number of artists were inspired by the eruption of Mount St. Helens, including Marilyn Bridges. See Patricia Grieve Watkinson, "Mount St. Helens: An Artistic Aftermath," *Art Journal* (Fall 1984): 259–268.

71. Emmet Gowin, cited in Jock Reynolds, "Above the Fruited Plain: Reflections on the Origins and Trajectories of Emmet Gowin's Aerial Landscape Photographs," *Emmet Gowin: Changing the Earth, Aerial Photographs* (New Haven: Yale University Art Gallery, 2002), 144.

72. Reynolds, "Above the Fruited Plain," *Emmet Gowin: Changing the Earth, Aerial Photographs*, 144.

73. Emmet Gowin, "Statement," April 1994, reprinted in *Emmet Gowin: Changing the Earth, Aerial Photographs*, frontispiece.

74. Reynolds, "Above the Fruited Plain," *Emmet Gowin: Changing the Earth, Aerial Photographs*, 146.

75. Robert A. Sobieszek, "Archaeopsychic Vistas: The Lake Project of David Maisel," *David Maisel: The Lake Project* (Tucson, AZ: Nazraeli Press, 2004), n.p.

76. David Maisel, "Report from the Lake I," *David Maisel: The Lake Project*, n.p.

77. David Maisel, "Report from the Lake V," *David Maisel: The Lake Project*, n.p.

78. Sobieszek, "Archaeopsychic Vistas," *David Maisel: The Lake Project*, n.p.

79. To combat the poisonous dust storms, the lake has been re-flooded since 2001, to a depth of a few inches; it remains a dead lake.

80. Sobieszek, "Archaeopsychic Vistas," *David Maisel: The Lake Project*, n.p.

81. David Maisel, "Report from the Lake IV," *David Maisel: The Lake Project*, n.p.

82. Terry Evans, *The Inhabited Prairie* (Lawrence, KS: University of Kansas Press, 1998).

83. Terry Evans, *Disarming the Prairie* (Baltimore: Johns Hopkins Press, 1998), 3.

84. George Adelman, Director, Openlands project, in Terry Evans, *Revealing Chicago: An Aerial Portrait* (New York: Harry N. Abrams, 2005), 190.

85. Terry Evans, "Acknowledgments," *Revealing Chicago*, 189. Kate O'Neill, conversation with the artist, 20 April 2006.

86. Carol Ehlers, "Revealing an Artist: Terry Evans's Chicago Photographs," *Revealing Chicago: An Aerial Portrait*, 188.

87. Evans, *Disarming the Prairie*, 3.

88. Christine Temin, "View from the Top," *Boston Globe* (Sunday 17 July 2005).

89. Elizabeth S. Padjen, "Momentary Realism," *Air Lines: Photographs by Alex MacLean* (Salem, MA: Peabody Essex Museum, 2005), 8.

90. MacLean founded his own aerial photography business, Landslides, in 1975.

91. Bill McKibben, "Introduction," *Look at the Land: Aerial Reflections on America* (New York: Rizzoli, 1993).

92. Vicki Goldberg, "This Delicate, Patchwork Earth," in Marilyn Bridges, *The Sacred and Secular: A Decade of Aerial Photography* (New York: International Center of Photography, 1990), 12.

93. Marilyn Bridges, "Afterword," *Markings: Aerial Views of Sacred Landscapes* (Oxford: Phaidon, 1986), 84.

94. Marilyn Bridges, "Aerial Markings," in Milbry Polk and Mary Tiegreen, *Women of Discovery: A Celebration of Intrepid Women Who Explored the World* (New York: Clarkson Potter, 2001), 200.

95. Marilyn Bridges, interview with Vicki Goldberg, cited in Goldberg, "This Delicate, Patchwork Earth," *The Sacred and Secular*, 11.

96. Marilyn Bridges, "Afterword," *Egypt: Antiquities from Above* (Boston: Bulfinch Press, 1996), 126.

97. Ibid.

98. Adriel Heisey, "Images Snatched from a Dream," *From Above: Images of a Storied Land* (Albuquerque, NM: The Albuquerque Museum, and Tucson: Center for Desert Archaeology, 2004), 26.

99. Grace Schaub, "Adriel Heisey, Aerial Photographer," *Photographer's Forum* (Spring 2001): 46–54.

100. Heisey, "Images Snatched from a Dream," *From Above: Images of a Storied Land*, 35.

101. William H. Doelle, "Archaeology from Above: Ways of Seeing," *From Above: Images of a Storied Land*, 20.

102. Ibid., 12.

103. Heisey, "Images Snatched from a Dream," *From Above: Images of a Storied Land*, 34.

104. Ibid., 32.

105. Sophie Ristelhueber, "Artist's statement," 4 April 1998, cited in Cheryl Brutvan, *Sophie Ristelhueber: Details of the World* (Boston: MFA Publications, 2001), 11–12.

106. Sophie Ristelhueber, cited in Brutvan, *Sophie Ristelhueber: Details of the World*, 137.

107. Cited in Ann Hindry, *Sophie Ristelhueber* (Paris: Hazan, 1998), 76.

108. Olivo Barbieri, "site specific _ montreal 04," in André Lortie, ed., *The Sixties: Montreal Thinks Big* (Montreal: Canadian Centre for Architecture, 2004).

109. Olivo Barbieri, *site specific _ LAS VEGAS 05: Learning from Las Vegas, again?* (Toronto: WONDER inc., 2005).

110. Robert Venturi, Denise Scott Brown, Steven Izenour, *Learning from Las Vegas* (Cambridge, MA: The MIT Press, 1972), cited in Barbieri, *site specific _ LAS VEGAS 05*, n.p.

111. Olivo Barbieri, "In Focus: From a conversation with Olivo Barbieri and John Shnier, at Bar One, Toronto, 2005," *site specific _ LAS VEGAS 05*, n.p.

112. Fernando Castro, "Esteban Pastorino Díaz: A View from Somewhere," *Aperture* 181 (Autumn 2005): 54.

113. Esteban Pastorino Díaz, email interview with Ariel Pittmann, 17 April 2006.

PLATES

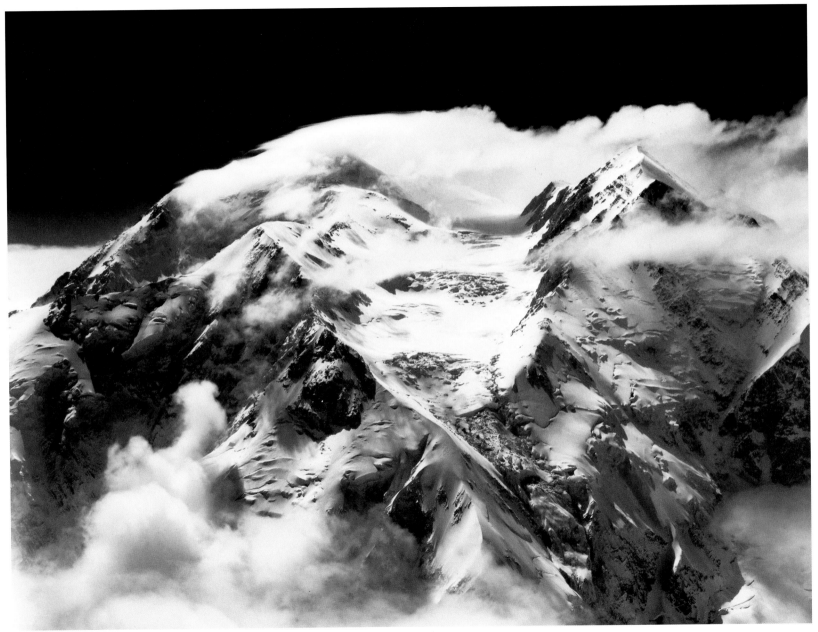

1. Bradford Washburn, *Windstorm, Mount McKinley, Alaska, 1942*, gelatin silver print, 16 x 20 in., courtesy of Panopticon Gallery, Boston, MA

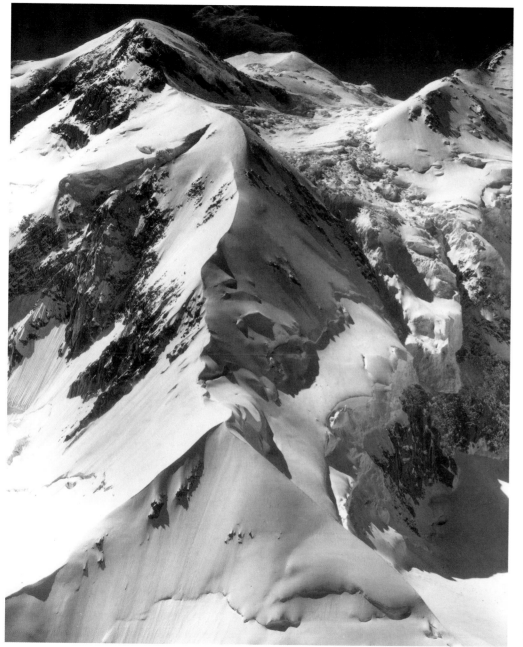

2. Bradford Washburn, *Karstens Ridge, Mount McKinley, Alaska, 1966*, gelatin silver print, 16 x 20 in., courtesy of Panopticon Gallery, Boston, MA

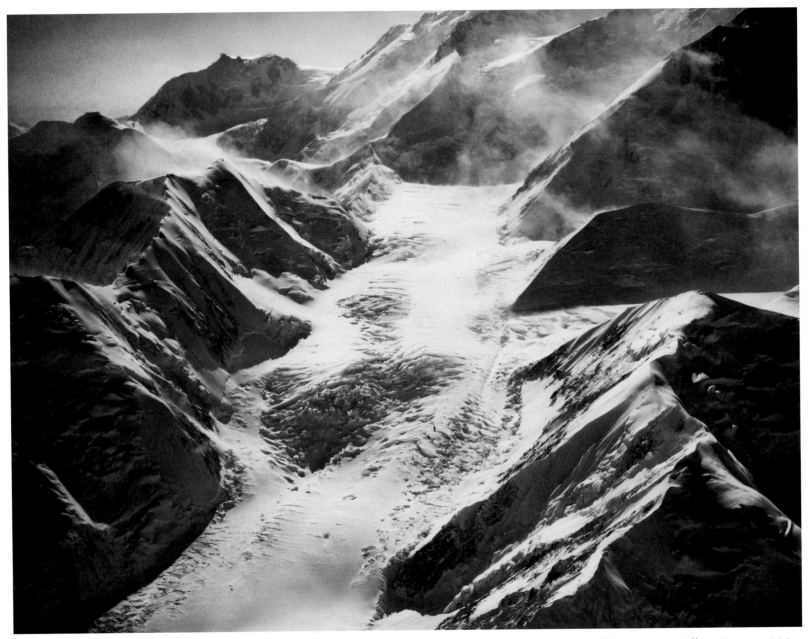

3. Bradford Washburn, *Windstorm, Muldrow Glacier, Alaska, 1947*, gelatin silver print, 16 x 20 in., courtesy of Panopticon Gallery, Boston, MA

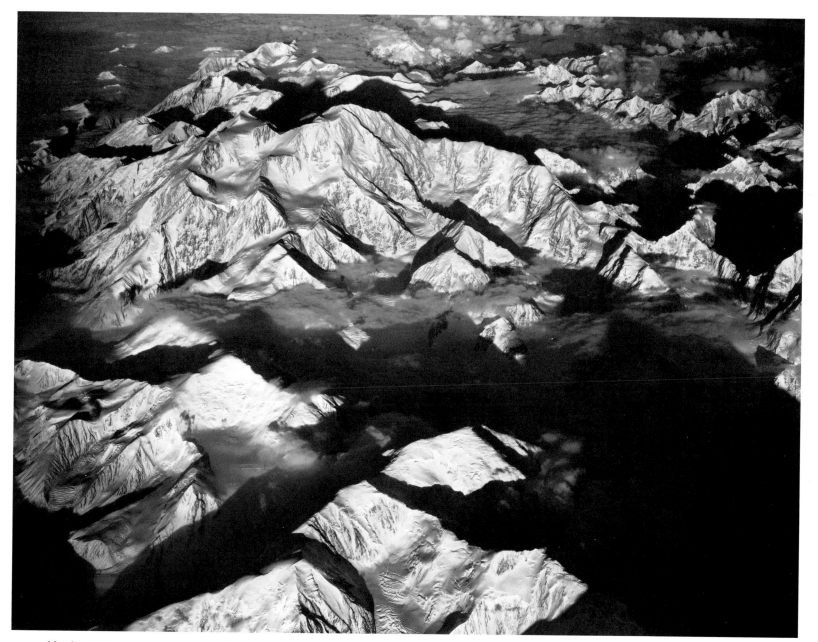

4. Bradford Washburn, *Sunset at 41,000 feet, Mount McKinley, Alaska, 1978*, gelatin silver print, 16 x 20 in., courtesy of Panopticon Gallery, Boston, MA

5. William Garnett, *Ploughed Field, Arvin, Calif. (Vertical Aerial, 500 ft.)*, 1952, gelatin silver print, 18 x 14½ in., © William A. Garnett, courtesy of Polaroid Collections, Waltham, MA

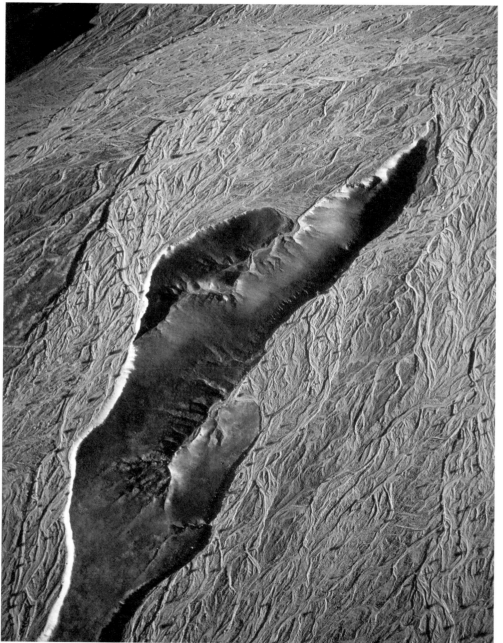

6. William Garnett, *Hill Projecting Through Alluvial Fan, Death Valley, Calif. (Oblique Aerial)*, 1953, gelatin silver print, 18 x 15 in., © William A. Garnett, courtesy of Polaroid Collections, Waltham, MA

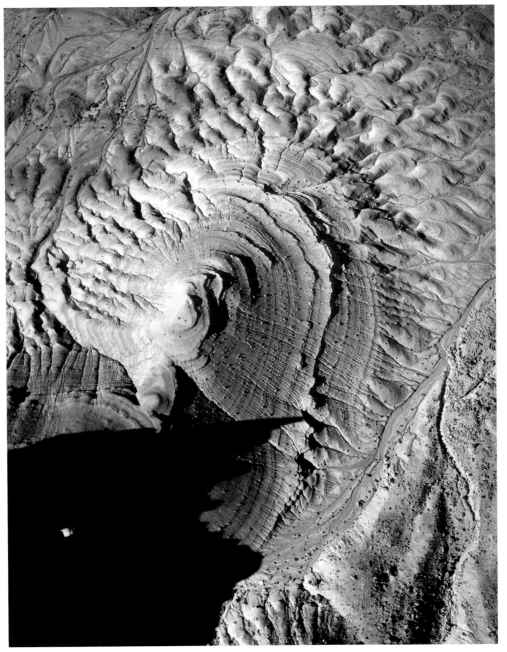

7. William Garnett, *Butte, Marble Canyon, Arizona (Vertical Aerial, 1000 ft.)*, 1954, gelatin silver print, 18 x 15 in., © William A. Garnett, courtesy of Polaroid Collections, Waltham, MA

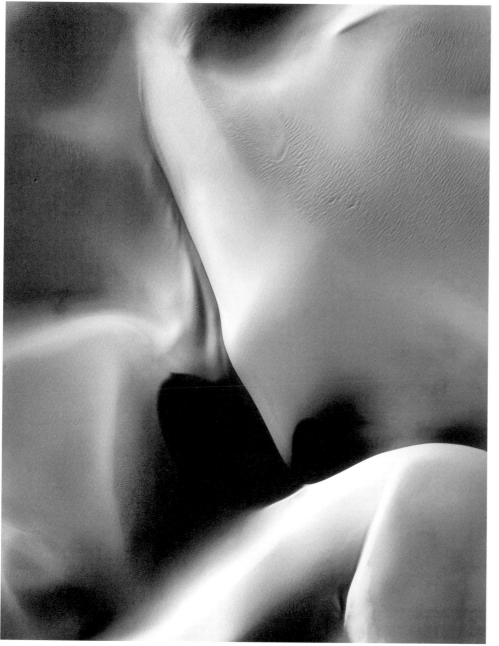

8. William Garnett, *Nude Dune, Death Valley, Calif. (Vertical Aerial, about 500 ft.)*, 1954, gelatin silver print, 18 x 15 in., © William A. Garnett, courtesy of Polaroid Collections, Waltham, MA

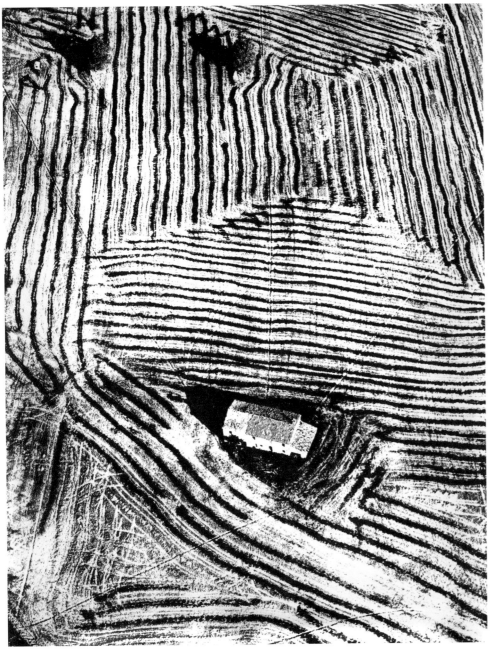

9. Mario Giacomelli, *Paesaggio 408*, 1970s, gelatin silver print, 12 x 16 in., courtesy of Robert Klein Gallery, Boston, MA

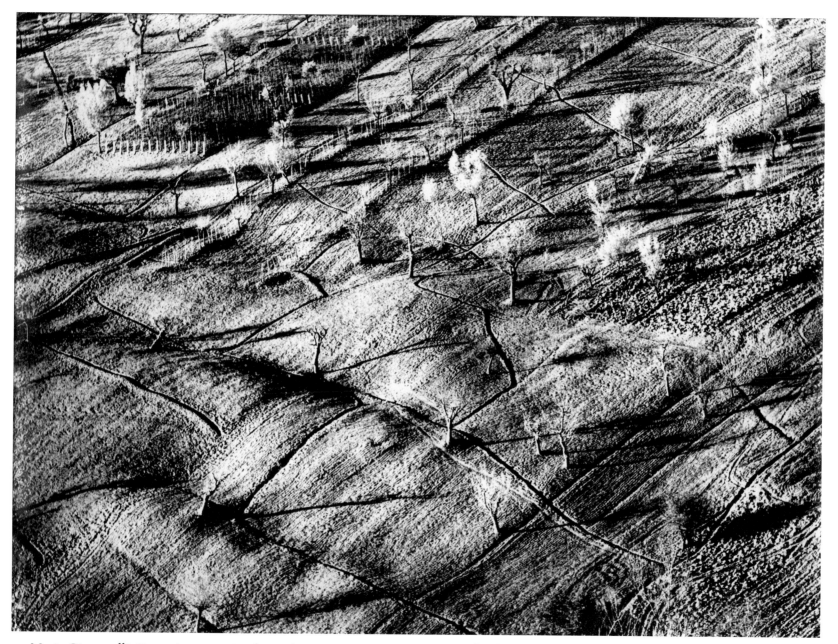

10. Mario Giacomelli, *Paesaggio 290*, 1976, gelatin silver print, 12 x 16 in., courtesy of Robert Klein Gallery, Boston, MA

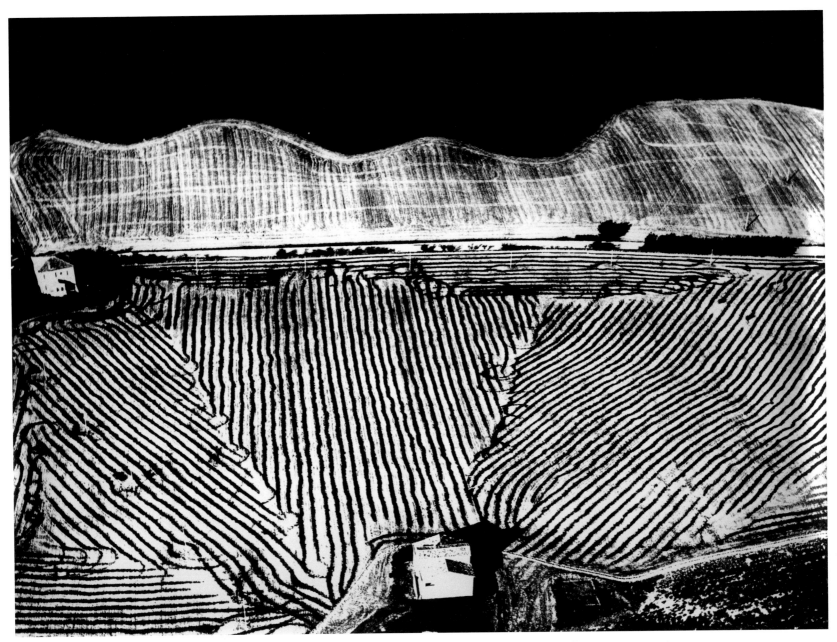

11. Mario Giacomelli, *Paesaggio 288*, 1970, gelatin silver print, 12 x 16 in., courtesy of Robert Klein Gallery, Boston, MA

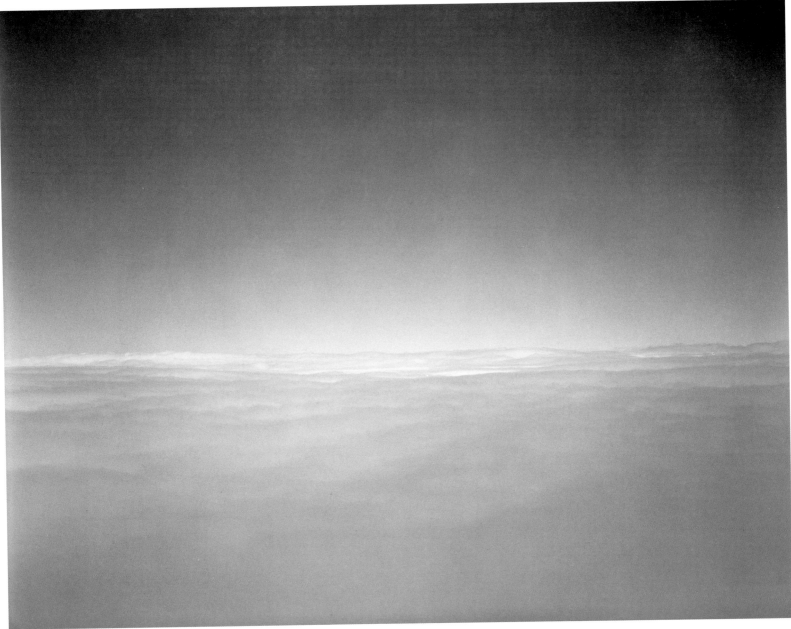

12. Barbara Bosworth, *Untitled Aerial View* from the series *Rising*, 2000, gelatin silver print, 20 x 24 in., courtesy of the artist

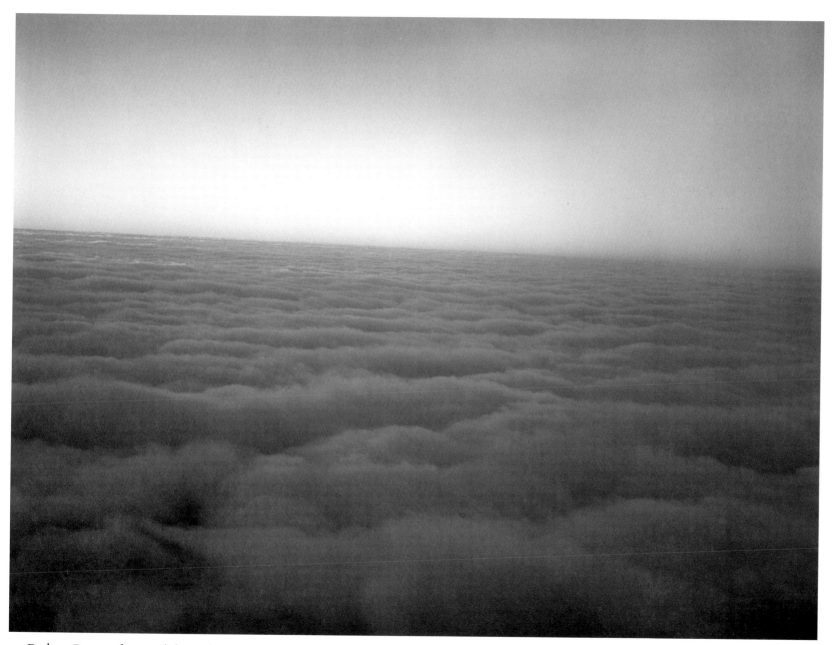

13. Barbara Bosworth, *Untitled Aerial View* from the series *Rising*, 2000, gelatin silver print, 20 x 24 in., courtesy of the artist

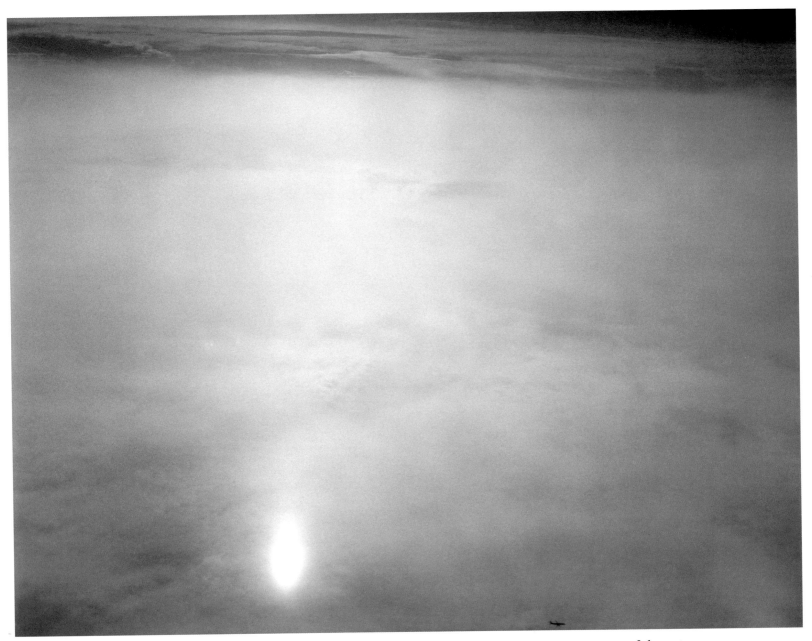

14. Barbara Bosworth, *Untitled Aerial View* from the series *Rising*, 2003, gelatin silver print, 20 x 24 in., courtesy of the artist

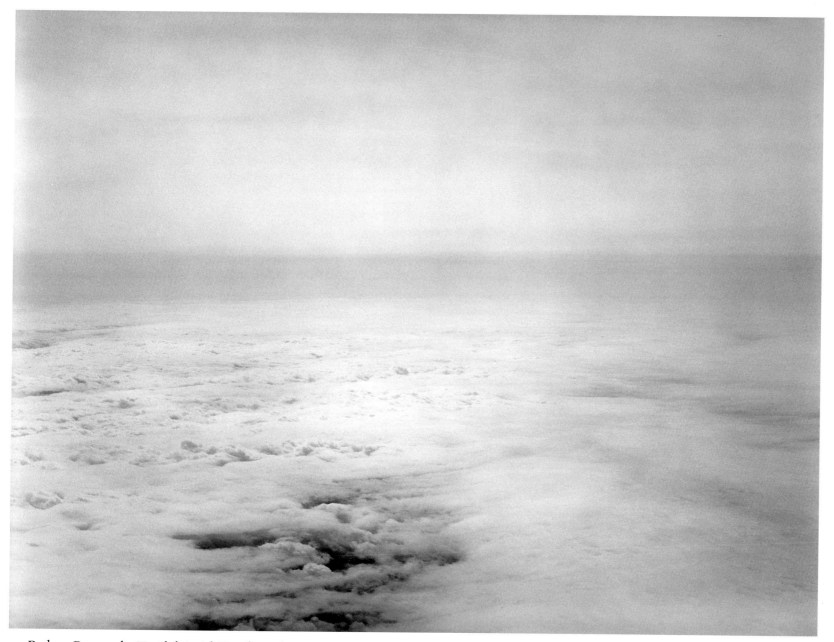

15. Barbara Bosworth, *Untitled Aerial View* from the series *Rising*, 2001, gelatin silver print, 20 x 24 in., courtesy of the artist

16. Frank Gohlke, *Aerial View: Fir and Hardwood Forest Outside Blast Zone. Approximately Twenty Miles from Mount St. Helens*, 1981, gelatin silver print, 30 x 40 in., courtesy of the artist

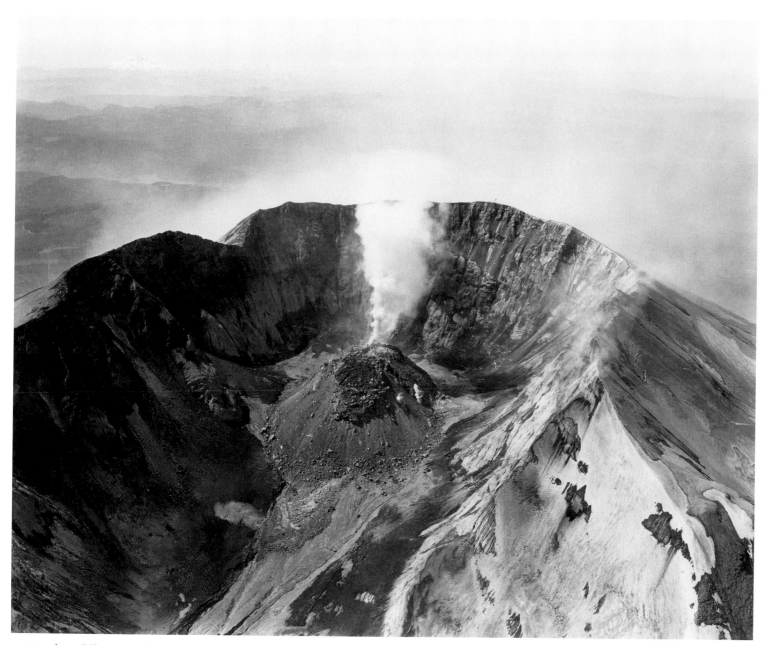

17. Frank Gohlke, *Aerial View: Looking South at Mount St. Helens Crater and Lava Dome, Mount Hood and Mount Jefferson in the Distance, Airplane in Crater*, 1982, gelatin silver print, 30 x 40 in., courtesy of the artist

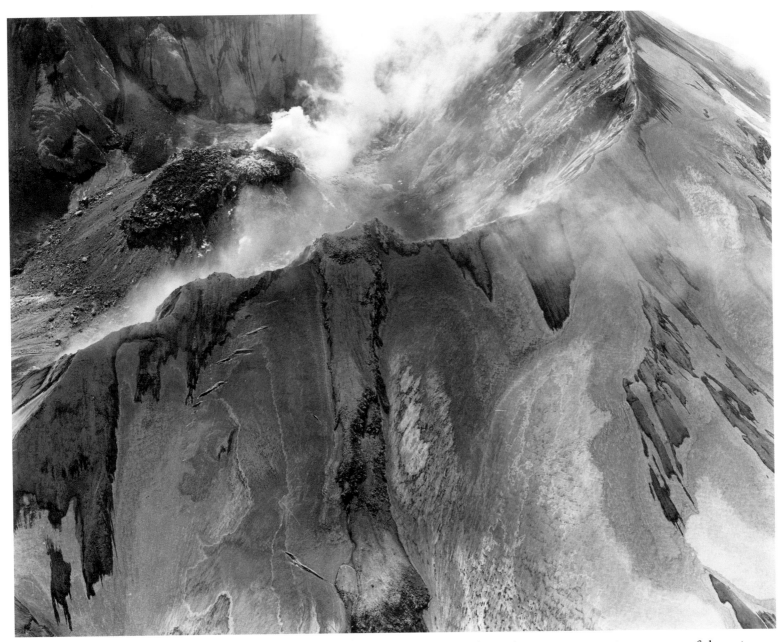

18. Frank Gohlke, *Aerial View: Mount St. Helens Rim, Crater, and Lava Dome,* 1982, gelatin silver print, 30 x 40 in., courtesy of the artist

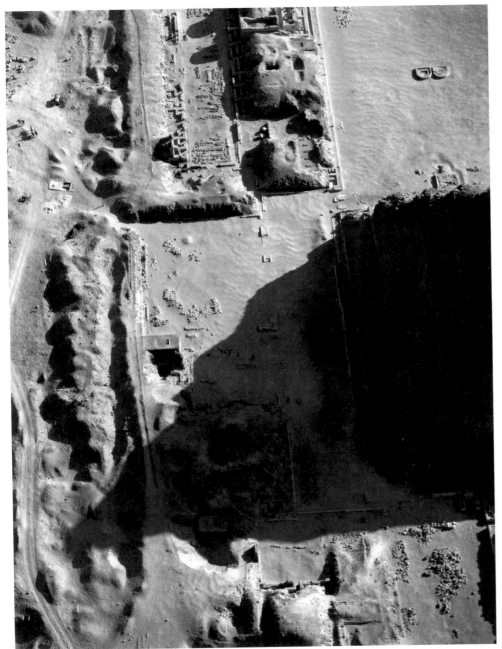

23. Marilyn Bridges, *Stepped Pyramid of Djoser with Shadow, Saqqara,* 1993, gelatin silver print, 20 x 24 in., courtesy of the artist

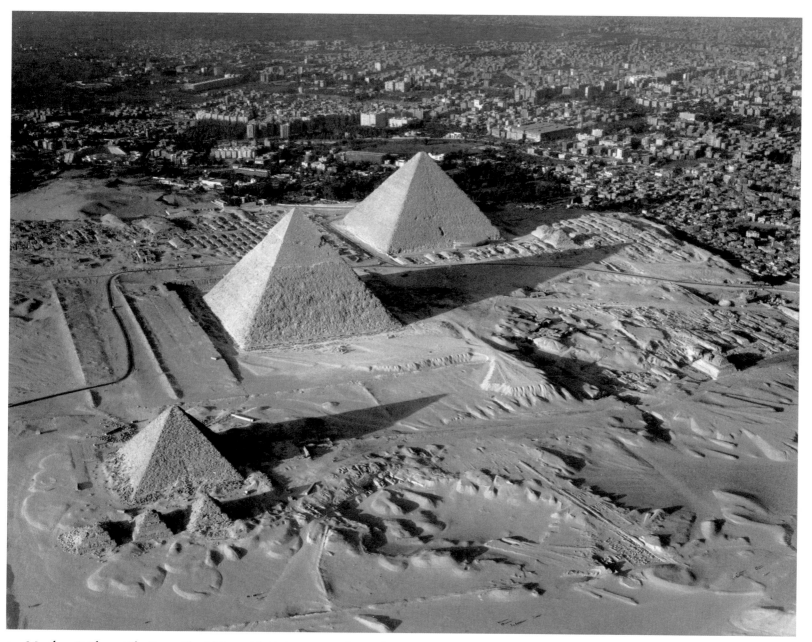

24. Marilyn Bridges, *The Pyramids of Giza with Cairo*, 1993, gelatin silver print, 20 x 24 in., courtesy of the artist

25. Marilyn Bridges, *Temple of Khons, Karnak*, 1993, gelatin silver print, 20 x 24 in., courtesy of the artist

EMMET GOWIN

19. Emmet Gowin, *Pivot Irrigation near the One Hundred Circle Farm and the McNary Dam on the Columbia River, Washington*, 1991, toned gelatin silver print, 14 x 11 in., courtesy of the artist

20. Emmet Gowin, *The Buffalo Jump Called Chugwater and an Irrigation Pivot Near Wheatland, Wyoming*, 1991, toned gelatin silver print, 14 x 11 in., courtesy of the artist

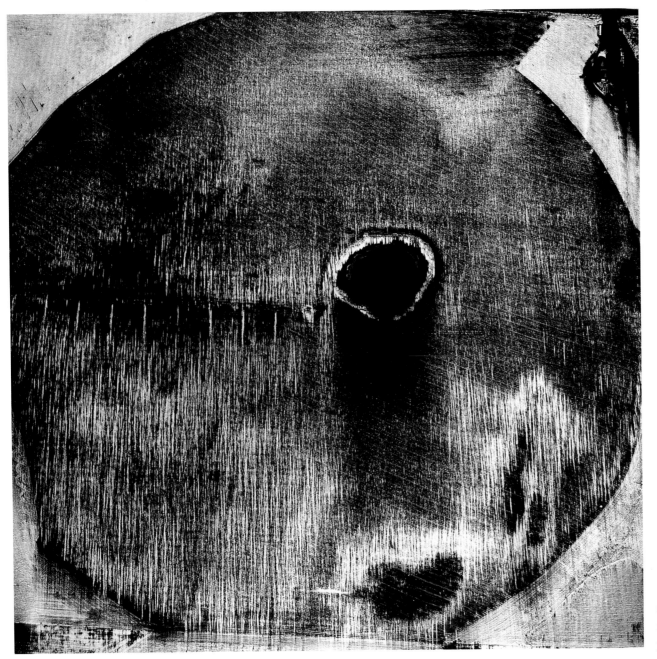

21. Emmet Gowin, *Snow Over Pivot Agriculture Near Liberal, Kansas*, 1995, toned gelatin silver print, 14 x 11 in., courtesy of the artist

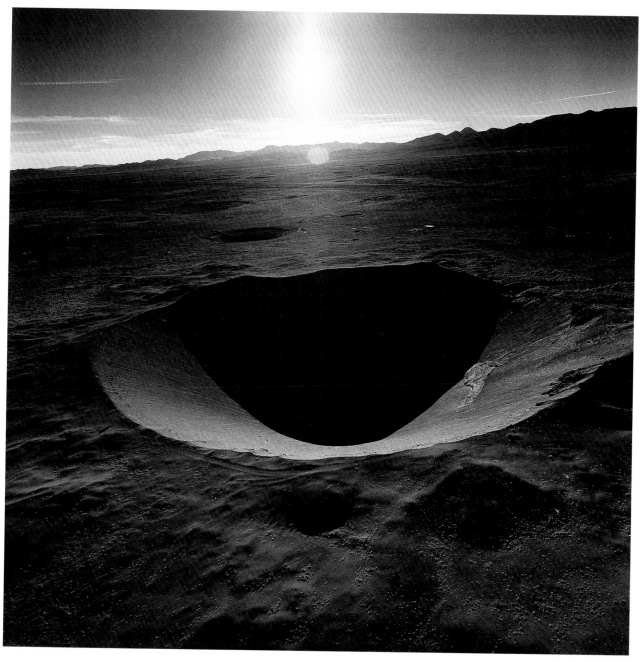

22. Emmet Gowin, *Sedan Crater, Northern End of Yucca Flat, Nevada Test Site*, 1996, toned gelatin silver print, 14 x 11 in., courtesy of the artist

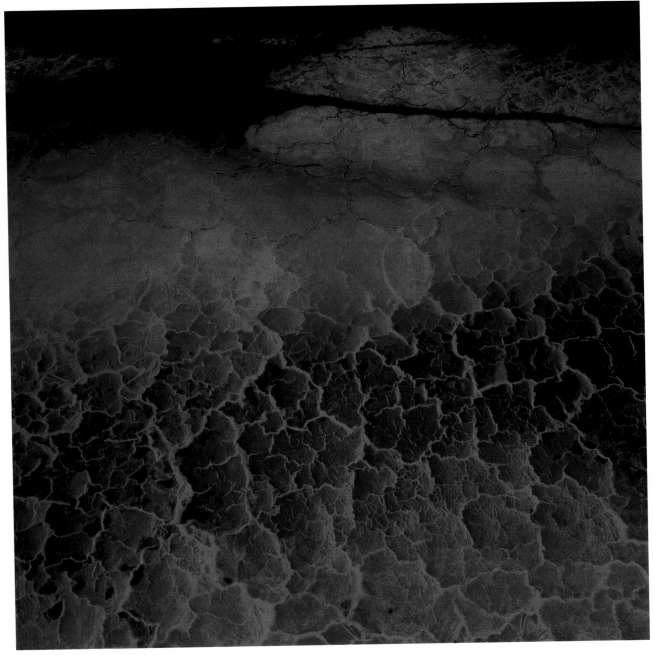

26. David Maisel, *The Lake Project #2*, 2001-2003, C-print, 29 x 29 in., courtesy of the artist and Miller Block Gallery, Boston, MA

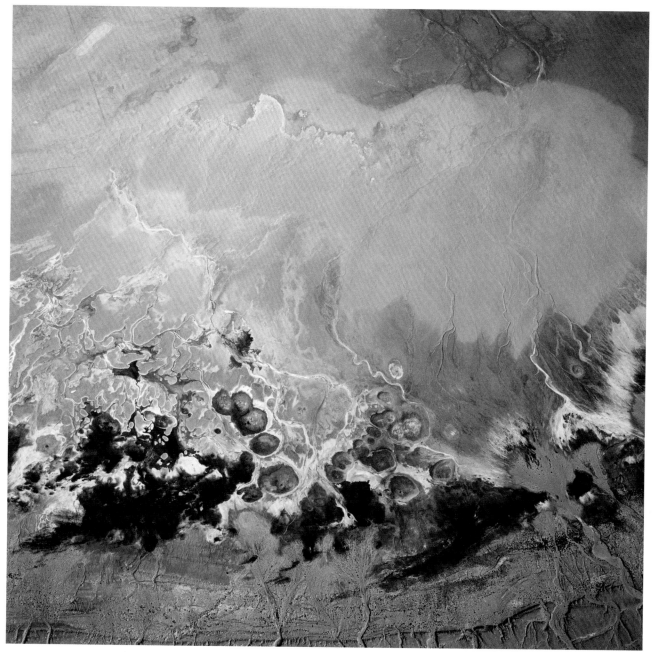

27. David Maisel, *The Lake Project #15*, 2001–2003, C-print, 29 x 29 in., courtesy of the artist and Miller Block Gallery, Boston, MA

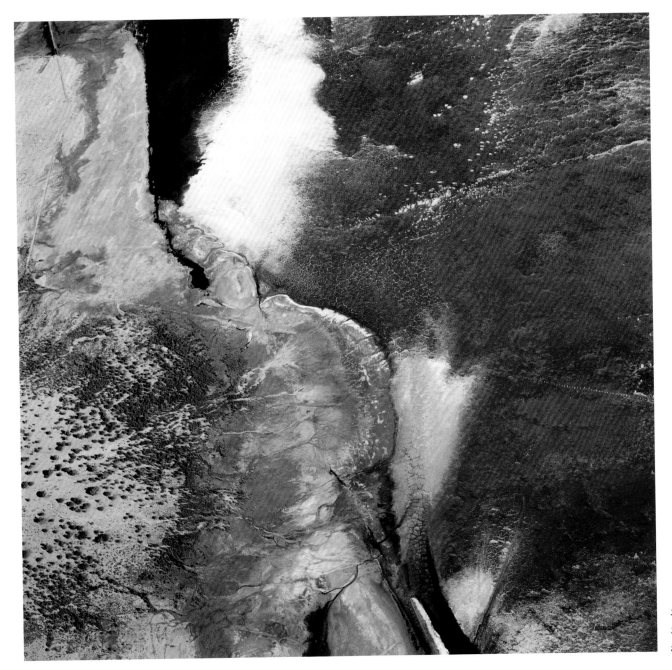

28. David Maisel, *The Lake Project #5*, 2001-2003, C-print, 29 x 29 in., courtesy of the artist and Miller Block Gallery, Boston, MA

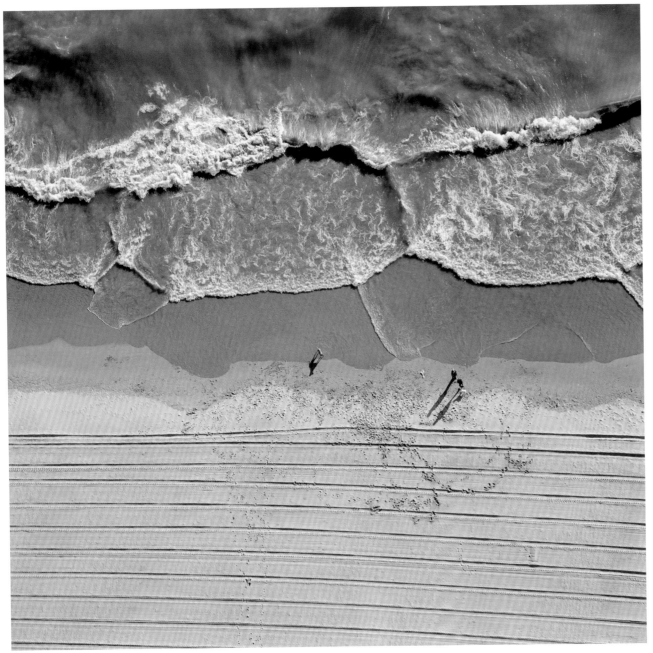

29. Terry Evans, *Oak Street Beach. Chicago, April 27, 2004*, archival digital print, 19 x 19 in., courtesy of Catherine Edelman Gallery, Chicago, IL

30. Terry Evans, *Smelt Season. Belmont Harbor, Chicago, April 23, 2004*, archival digital print, 19 x 19 in., courtesy of Catherine Edelman Gallery, Chicago, IL

31. Terry Evans, *North Avenue Beach. Chicago,
June 24, 2003*, archival digital print, 19 x 19 in.,
courtesy of Catherine Edelman Gallery,
Chicago, IL

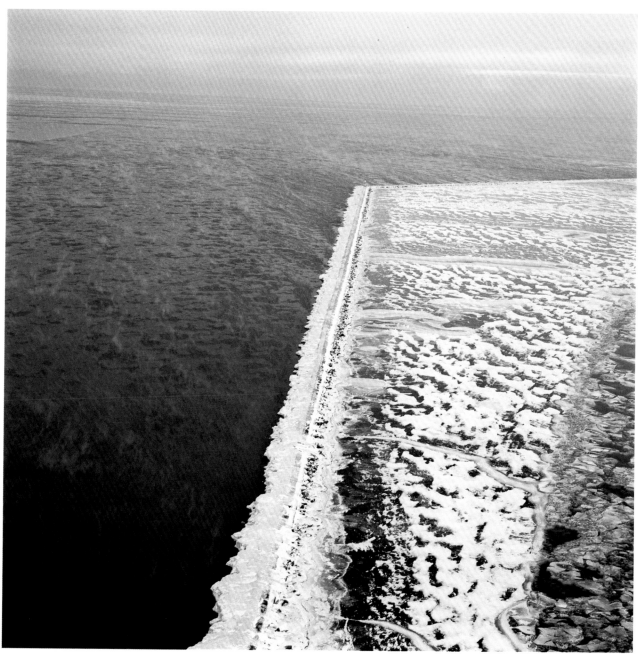

32. Terry Evans, *Jetty. Lakefront Near Downtown, Chicago, January 29, 2004*, archival digital print, 19 x 19 in., courtesy of Catherine Edelman Gallery, Chicago, IL

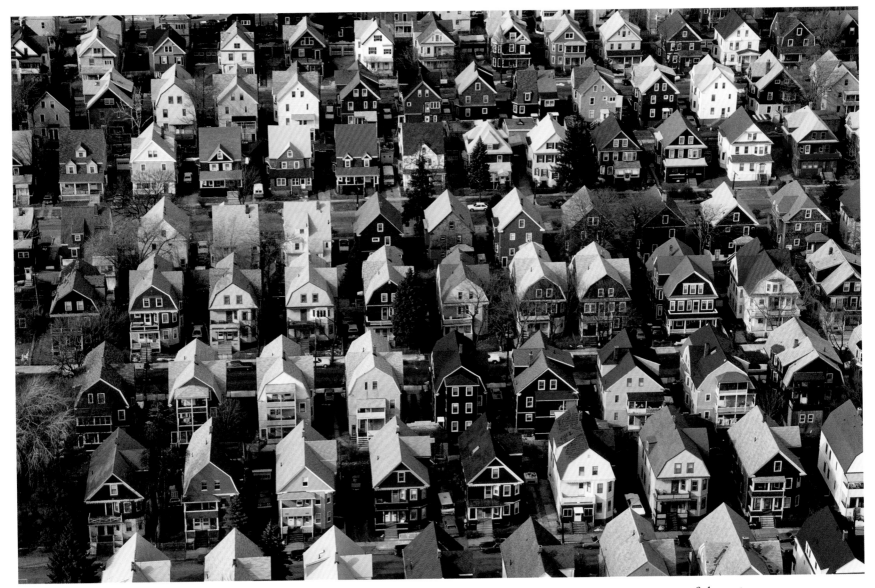

33. Alex MacLean, *Two-Family Houses in Streetcar Community, Somerville, Massachusetts*, 1983, C-print, 24 x 36 in., courtesy of the artist

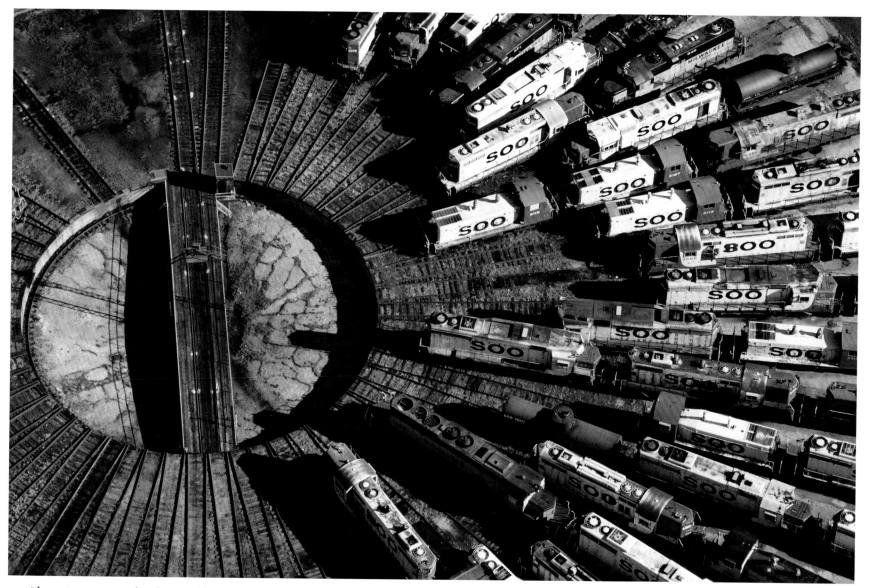

34. Alex MacLean, *Railroad Turntable, Minneapolis, Minnesota*, 1985, C-print, 24 x 36 in., courtesy of the artist

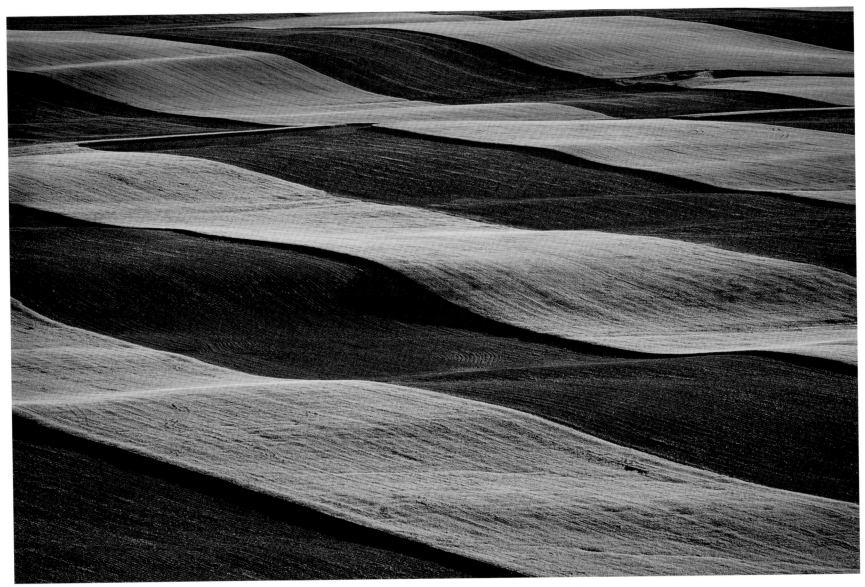

35. Alex MacLean, *Dryland Farming Field Near Shelby, Montana*, 1991, C-print, 24 x 36 in., courtesy of the artist

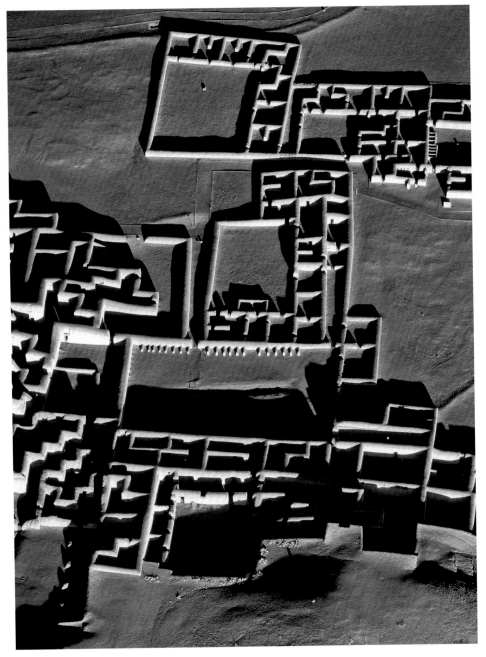

36. Adriel Heisey, *Roomblocks with Reconstructed Adobe Walls, Central Complex, Paquimé, Casas Grandes, Chihuahua, Mexico*, 2000, C-print, 20 x 24 in., courtesy of the artist

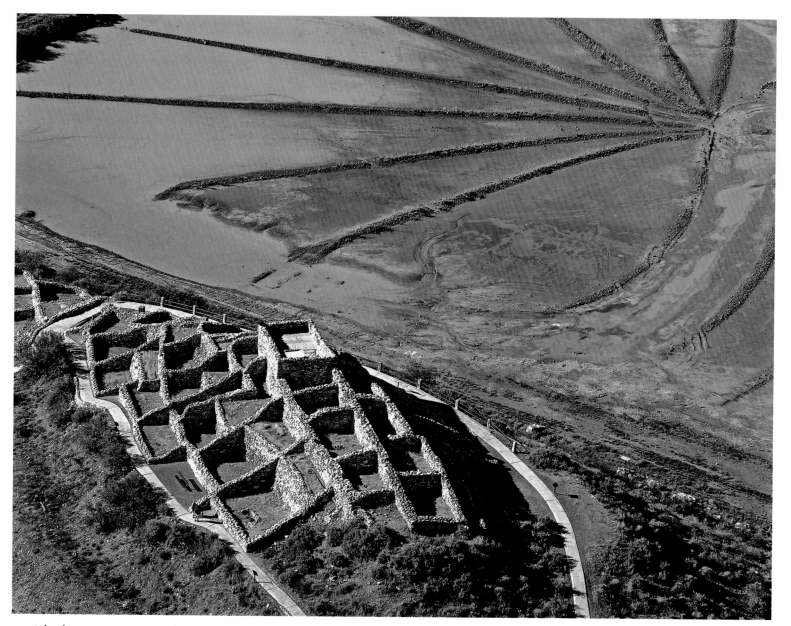

37. Adriel Heisey, *Sinagua Village with Tailings Pond, Tuzigoot National Monument, Verde River Valley, Arizona*, 1998, C-print, 20 x 24 in., courtesy of the artist

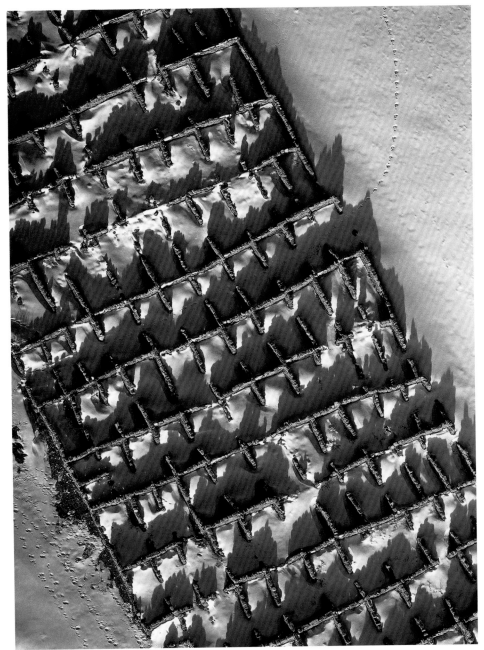

38. Adriel Heisey, *Pueblo Blocks in Snow, Puyé Pueblo, Santa Clara Indian Reservation, New Mexico*, 2001, C-print, 20 x 24 in., courtesy of the artist

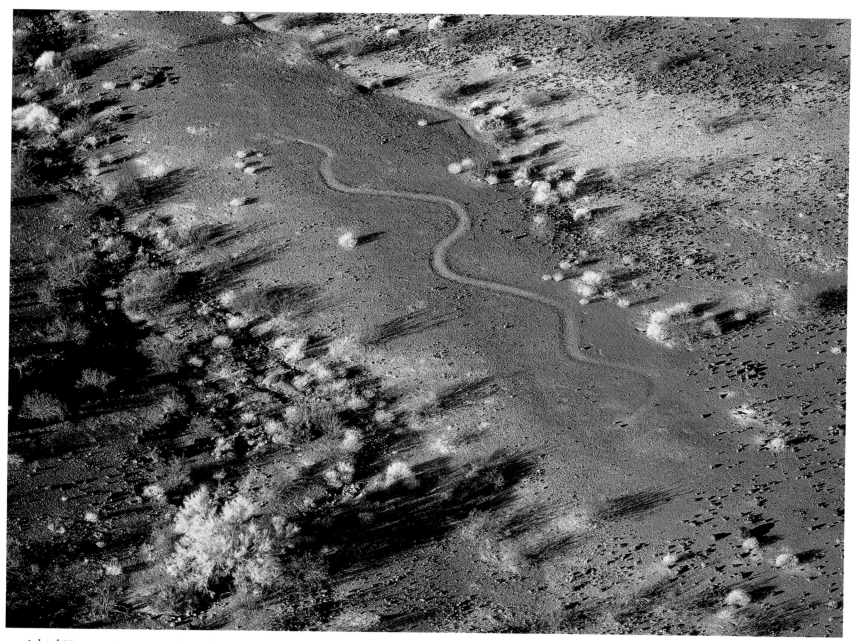

39. Adriel Heisey, *Serpent Intaglio with Palo Verde, Arizona*, 2000, C-print, 20 x 24 in., courtesy of the artist

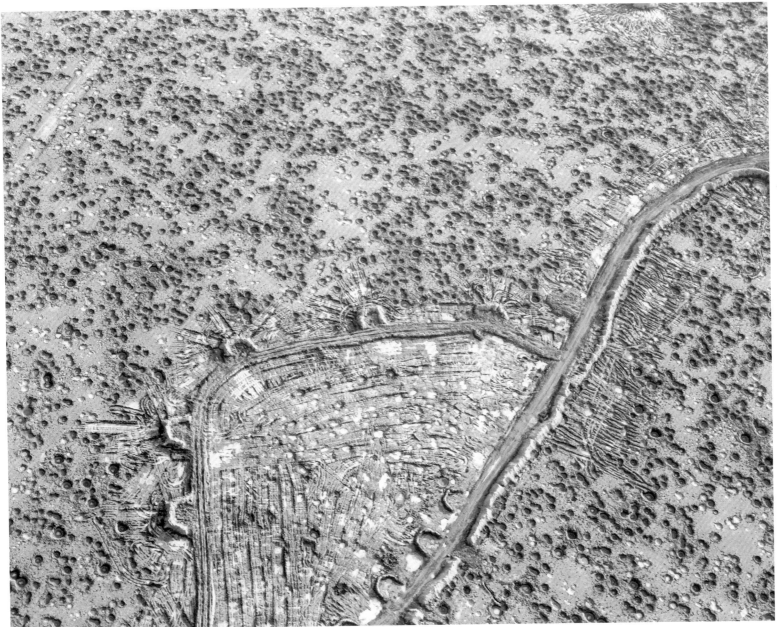

40. Sophie Ristelhueber, *FAIT series*, 1992, chromogenic color print, edition 1/3, 40 x 50 in., courtesy Albright-Knox Art Gallery, Buffalo, NY, George B. and Jenny R. Mathews Fund, 1997

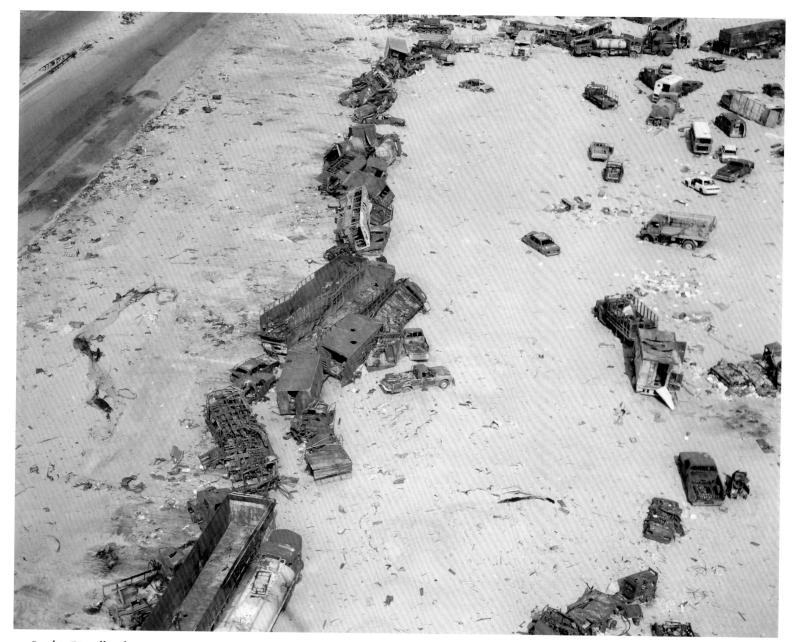

41. Sophie Ristelhueber, *FAIT series*, 1992, chromogenic color print, edition 1/3, 40 x 50 in., courtesy Albright-Knox Art Gallery, Buffalo, NY, George B. and Jenny R. Mathews Fund, 1997

42. Olivo Barbieri, *site specific_LAS VEGAS 05,* 2005, C-print, 48 x 68 in., courtesy of Yancey Richardson Gallery, New York, NY

43. Olivo Barbieri, *site specific_LAS VEGAS 05*, 2005, C-print, 48 x 68 in., courtesy of Yancey Richardson Gallery, New York, NY

44. Esteban Pastorino Díaz, *Belanio, Skopelos, Greece*, 2002, C-print, 16 x 20 in., courtesy of PDNB Gallery, Dallas, TX

45. Esteban Pastorino Díaz, *Village, Skopelos, Greece*, 2002, C-print, 16 x 20 in., courtesy of PDNB Gallery, Dallas, TX

46. Esteban Pastorino Díaz, *Camiones en Cantera, Skopelos, Greece*, 2002, C-print, 16 x 20 in., courtesy of PDNB Gallery, Dallas, TX

47. Esteban Pastorino Díaz, *ΔHMAPXEION, Skopelos, Greece*, 2002, C-print, 16 x 20 in., courtesy of PDNB Gallery, Dallas, TX

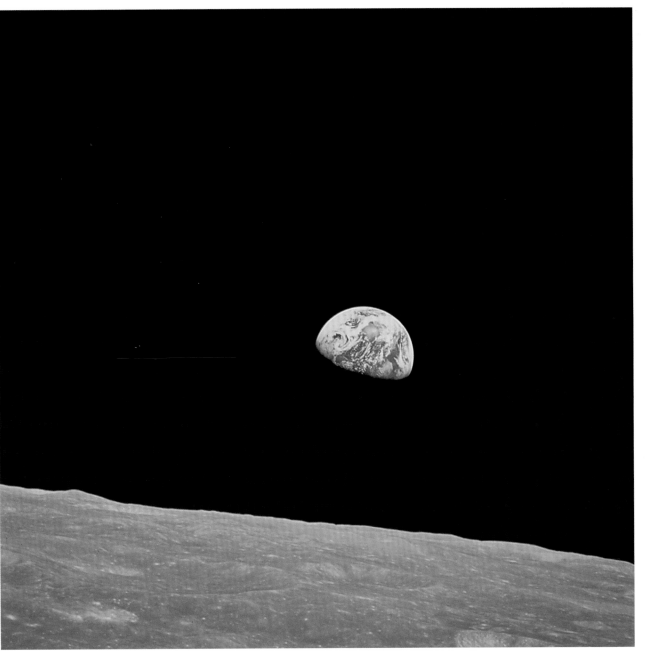

48. NASA, *Earthrise–Apollo 8 (William Anders)*, 1968, laser print, 20 x 20 in., courtesy of Polaroid Collections, Waltham, MA

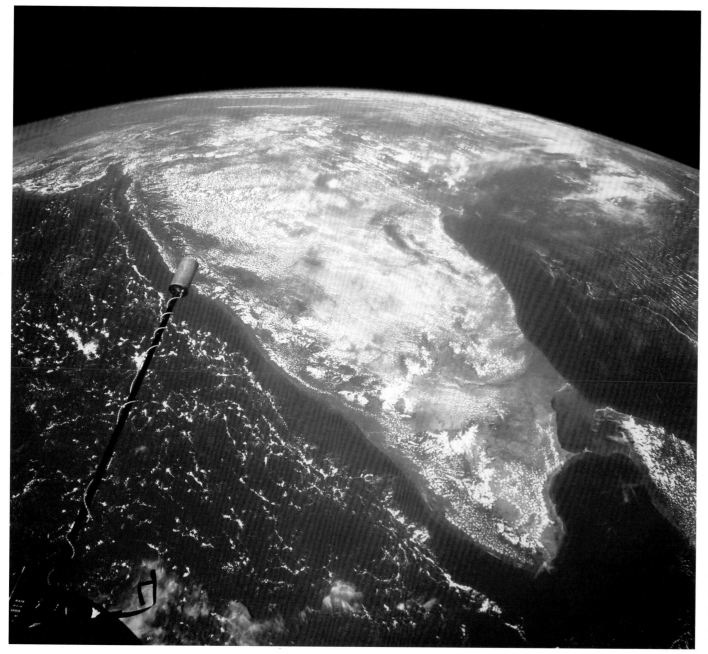

49. NASA, *View of India and Ceylon as seen from Gemini 11 Spacecraft (Richard Gordon)*, 1966, laser print, 18 x 20 in., courtesy of Polaroid Collections, Waltham, MA

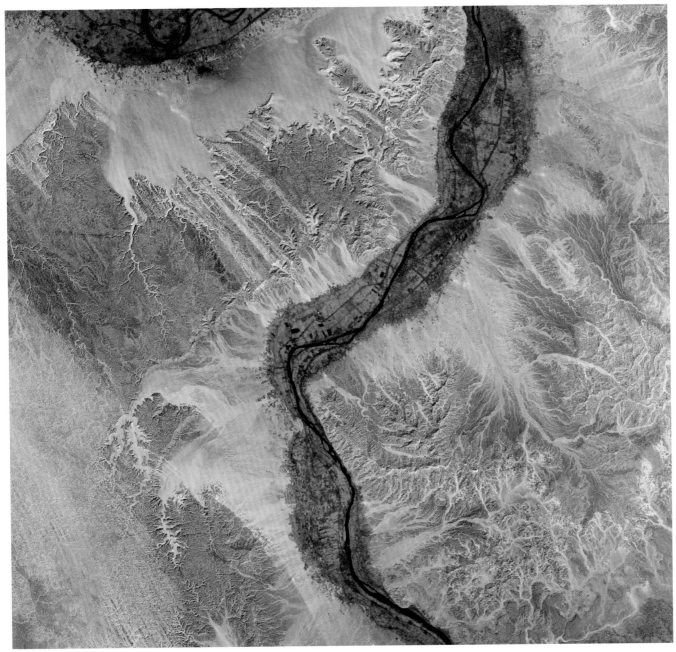

50. Landsat 5, *Image of the Luxor Region, Egypt*, 1986, inkjet print from false-color digital source, 36 x 40 in., courtesy of Center for Remote Sensing, Boston University

SPACE IMAGES

Dr. Farouk El-Baz

During the past 40 years, imaging the Earth from space progressed from simple photographs to digital multi-spectral and radar data. The Apollo astronauts first used color film, which defined the form and components of surface features. Ancient rocks, with much iron and other dark elements, appeared brown, sediments like limestone looked bright, and sands showed up in yellow tones.

The second generation of images was relayed by digital sensors. NASA's Landsat program initiated these in 1972. From the spacecraft altitude of 920 kilometers, an instrument sensed rows of tiny spots, measured the intensity (from 0 to 250) of reflected light from each spot, and beamed the numbers to ground receiving stations. There, the data were archived, processed, and distributed for study and analysis.

Detail in space images depends upon: first, the altitude of the spacecraft—the lower the orbit, the higher the resolution—and second, the focal length of the camera lens—the longer the length, the greater the detail. Furthermore, digital imaging from space allows the use of filters to separate reflected light into various wavelengths. These include infrared and thermal bands that measure differences in the temperatures of the exposed surfaces and help identify economic mineral resources. Another use of remote digital imaging is repeat coverage of the same area from the same height by the same sensor. By overlaying two datasets using computer software, accurate "change detection" maps are produced for the evaluation of environmental change due to natural as well as man-made processes.

The third generation of satellite images was provided by radar remote sensing. As opposed to the passive sensing of reflected sunlight, a radar sensor emits waves toward the Earth and records the returned beam, or echo. One unique characteristic of radar is an ability to penetrate dry, fine-grained sand and reveal hidden topography. This makes it possible to unveil courses of former rivers beneath desert sand, and hence, to locate groundwater resources in arid environments.

The variety of imaging systems does not compare to that of depicted features.

The Earth displays intricate compositions in various hues. Each view hints to the origin and the history of evolution of the depicted landforms. It is for these reasons that satellite images have been applied to numerous fields of studying the Earth and its environment.

The Boston University Center for Remote Sensing was established in 1986 to apply advanced imaging techniques in the fields of archaeology, geography, and geology. Archaeological applications included using space-age instruments to unveil the contents and measure environmental parameters within a sealed boat chamber at the base of the Great Pyramid of Giza. Similarly, infrared and ultraviolet imaging revealed the cause of deterioration of the wall paintings (by salt crystallization) in the tomb of Nefertari near Luxor, Egypt, prior to the restoration of the paintings.

Applying remotely sensed data in geography and environmental studies at the Center played a key role in classifying tree species in the California forests; detecting changes due to agricultural practices in semiarid regions worldwide; and identifying global changes in land cover and land-use patterns. Change-detection techniques were also used to map the detrimental effects of the burning of oil wells and the movement of heavy military vehicles on the desert surface of Kuwait in the Gulf War of 1991.

Geological applications emphasized the study of desert landforms and their comparison with the surface features of Mars. Techniques used to count sand dunes in the desert were applied to resolve the controversy of the number of people in the "Million Man March" of 1995. Furthermore, both multi-spectral and radar images were used at the Center to identify locations of new groundwater resources in the deserts of Egypt, Oman, and the United Arab Emirates. Based on the innovative research approach in such varied applications, the Center was selected by NASA in 1997 as a "Center of Excellence in Remote Sensing."

Farouk El-Baz is the Director of the Boston University
Center for Remote Sensing

CATALOGUE ENTRIES

OLIVO BARBIERI

For the past several years, Olivo Barbieri has been photographing large cities for a project titled "site specific." To date, the Italian photographer has explored six cities: Rome, Amman, Shanghai, Los Angeles, Montreal, and, most recently, Las Vegas. With a helicopter as his tripod, he allows nothing to obstruct his view of the cities' famous sites. Barbieri works with a large-format camera equipped with a perspective-correcting lens; the lens can tilt and shift, altering its relationship with the film. By manipulating this relationship, he can choose what will be in or out of focus.

Dissatisfied with the democracy of straight photography, Barbieri admits to a desire for more control, and the ability to create a more directed viewpoint. Barbieri leaves his chosen focal point in sharp focus while blurring out areas he deems insignificant. The distortion of large portions of the image clears away the imperfections of the city. The lens also alters the subject angles, and the skewed perspective gives the photographs the feeling of an intricate, elaborate model.

This model effect becomes even more pronounced when applied to the eclectic architecture of pastiche on the Las Vegas strip. Las Vegas, perhaps more than any other city, employs an incredibly diverse group of architectural structures—at times stealing well-known forms. The city relies on its architecture to sell itself. In one photograph, Barbieri further condenses the forms and saturates the colors of the Venetian casino, creating an artificial version of a watery Italian cityscape that floats on an artificial island amidst a vast Western desert. In another image of the Luxor casino, he flanks a fake sphinx and shiny pyramid with stepped structures reminiscent of building blocks.

Barbieri has always been interested in the urban landscape, our use of spaces, and how new architecture becomes integrated with the old. Acutely aware of the fragility of our current landscape, he views each city as a temporary, site-specific installation. He has chronicled, from the ground and the sky, the development of China's major cities since 1989. Las Vegas, like many of the cities in China, developed in a relatively short period and in an unplanned fashion. As tastes change, the city will adjust and abandon its previous landmarks without guilt.

Barbieri records, in his way, a brief moment of the city's history, and with these sunny, idealized views he depicts Las Vegas as the playground it seeks to be.

Katharine Urbati

BARBARA BOSWORTH

"You must not blame me if I do talk to the clouds," Henry David Thoreau wrote to a friend in an 1842 letter about his recently deceased brother, John.[1] Barbara Bosworth's cloud photographs echo this quotation from the nineteenth-century Trancendentalist, poet, and essayist; they present a visual analogy of spiritual reverie enacted through a dialogue with the clouds. The poetics of a cloudscape evoke romantic, ethereal, or dreamlike imagery and can signify cosmic places. At the same time, clouds are phenomena of weather, visible masses of particles of condensed vapor.

The desire to see above the clouds is a historically primal, human aim—the photographers grouped here demonstrate that technical advances allow such a vision. Barbara Bosworth's gesture—enacted by boarding a commercial jet and capturing her images through a passenger window—is unique in that she photographs clouds from above, omitting any hint of the landscape beneath them. Using her 8x10-inch camera, Bosworth photographs cloudscapes in both color and black and white, emphasizing that she seeks not scientific fact but "more about the feeling" conveyed in the cloud forms.[2]

For Bosworth, this work represents several layers of meaning. Initially, her sky projects (beginning with images of stars, then clouds, and now birds) were part of a personal investigation of the spiritual—an ethos not unlike Thoreau's. At the same time, the work was also the result of the pragmatic eye of a seasoned photographer. Bosworth recounts that her cloud work began during a 2000

1. Barbara Bosworth sent this quotation as part of an email correspondence. F. B. Sanborn, ed., *The Writings of Henry David Thoreau: Familiar Letters*, v. VI (New York: AMS Press, Inc., 1968), 43.
2. All statements by Barbara Bosworth are from Ginger Elliott Smith's phone interview with the artist, 30 March 2007.

commercial flight to visit her mother, triggered by childhood memories of seeing the world rushing by through a car window frame. With her large-format camera always near at hand during travel, she instinctively set it up in mid-flight and began shooting downward through the small window of the airplane. Bosworth has continued the project on approximately twenty-five subsequent flights.

As a landscape photographer, Bosworth views the topography of the clouds as a vista in and of itself—clouds and sky meet at a perceivable horizon line. She expresses "pure amazement" at the images she sees through the thick, double-paned window of the airplane. The four photographs selected here—all gelatin silver prints made between 2000 and 2003—have an otherworldly, ethereal quality. Two works resemble the sea, with even horizon lines meeting billowy masses that masquerade as waves. Another captures a sweeping white scene reminiscent of one of Earth's ice-covered poles. These images subtly remind us that this view, above the clouds, is a privilege of modernity. For instance, in the fourth image a microscopic plane flies near the bottom of the frame. Bosworth emphasizes that she is "unabashedly interested in making beautiful photographs," and her notion of beauty borders on the sublime.

<div align="right">Ginger Elliott Smith</div>

MARILYN BRIDGES

Marilyn Bridges has traveled the world photographing sacred sites created long ago. In the early 1990s, after securing the necessary permissions and filling out the essential documents, Bridges gained permission to fly above the ancient monuments of Egypt. Not only are her images a rarity in that such permission is rarely granted, but Bridges' intimate, oblique views and startling use of lights and darks create an unparalleled view of the monuments. Generally flying three to five hundred feet above the ground, Bridges highlights the structural depth of the forms, rather than creating flat abstractions as seen in so many other aerial photographs. The strong geometric forms seen in *Pyramid of Khephren, Giza* (1993) and *Temple of Khons, Karnak* (1993) seem to physically lift off from the photograph's surface. While shooting in the early morning or late in the day, Bridges creates vibrant, lengthy shadows that heighten the strong three-dimensionality of her sacred subjects.

Marilyn Bridges also uses strong lights and darks in her photographs to create a sense of powerful and personal emotion. A great sense of loneliness and melancholy pervades these astonishingly beautiful black-and-white photographs. In these views from a lofty "God's-eye view," the normal hustle and bustle of the Egyptian landscape is hauntingly absent. All that remain are the monuments, impressive in size and grandeur, a seemingly permanent part of the landscape. Although these ancient buildings have withstood the test of time, Bridges is saddened by the loss of the ancient civilization that once created them. Mortality is a universal preoccupation for those living along the Nile. These monuments, the pyramids and temples, are the culmination of their desire to put a permanent stamp on the landscape—a visual and physical communication with the gods. In *The Pyramids of Giza with Cairo* (1993), Bridges shares her intense longing to reawaken spiritual and emotional responses within the viewer.

Using juxtapositions of the marks left by ancient and modern man, Bridges comments on the impermanence of these sacred sites. Though the monuments have stood for thousands of years, vandalism and air pollution from the overcrowded cities have contributed to their deterioration.

<div align="right">Dorothy Nieciecki</div>

ESTEBAN PASTORINO DÍAZ

The photographs by Esteban Pastorino Díaz shown here are from an untitled aerial series shot primarily during a residency program at the Photographic Centre of Skopelos on Skopelos Island in Greece. This program is funded by an organization based in France (Pépinières européennes pour jeunes artistes). Instead of learning to fly, or hiring someone to take him up in an airplane, like the other photographers exhibited here, Pastorino Díaz makes his aerial images by attaching to a large kite a homemade 4x5-inch camera made of foamcore board with a wide-angle, fixed-focus lens (105 mm, f4.5). He thereby relinquishes his ability to frame the image as he sees it. He triggers his shutter via radio control. This method allows him to fully embrace the effects of chance on his artwork. Pastorino Díaz does not claim to have a political, documentary, or environmental motive behind his images. Instead he is trying to create a visual representation of his own "inner world" by making and selecting images intuitively, without the benefit of looking through the viewfinder.

Pastorino Díaz graduated from the College Otto Krause in Buenos Aires as a mechanical technician in 1990. He then studied as a mechanical engineer until 1993, when he shifted gears from engineering to photography—studying

in Argentina with Juan Travnik and Fabiana Barreda, two well-known Latin American photographers. His background in mechanical engineering has a strong influence on his art. He builds his own cameras and tweaks others that are commercially available so they suit his unique vision.

To create these images of the world as he sees it, Pastorino Díaz has crafted a camera capable of making the very large appear very small. He lifts this camera into the sky and leaves the decisive moment up to chance, and he consciously chooses to publish images of both work and leisure. These photographs are intended to manipulate the viewer's perception. At first glance they seem to be pictures of scale models, instead of aerial views of actual places. They look like close-ups of small objects rather than images of human-scale objects taken from far away. This aesthetic is disorienting, but it is also appealing. Pastorino Díaz's work substitutes images of the real world for symbols that represent his internal world. This substitution is an interesting inversion of Jean Baudrillard's explanation of the simulacrum. Instead of substituting signs of the real for reality, reality has been substituted for the symbols.

Ariel Pittman

TERRY EVANS

Terry Evans's 2005 series *Revealing Chicago* is a stunning *tour de force* of beautiful photographs made through research and public support. Shown in Chicago's Millennium Park during its second summer season, the series showcased one hundred pictures taken above and around Chicago during the course of over forty flights. Receiving support from Chicago's Cultural Affairs Department and area non-profit organizations, Evans met with a team of experts to consider areas of the Chicago landscape that deserved documentation. The resulting photographs blend a vivid formal quality with the questions of urban development and conservation facing Chicago at the start of the new millennium. In this project, she uses aerial photography to document the intersections of land and water in the Midwest, and the demarcations of different neighborhoods and landmasses in Chicago.

Photographing an urban environment was a new experience for Evans; prior to moving to Chicago in 1994, she had devoted much of her photography to the prairie around her home in Salina, Kansas. Evans began her relationship with the prairie in 1978, when she started photographing grasses, using pattern to understand the interplay of the many components in the undisturbed grasses. When she became interested in investigating the patterns of the prairie that had been subjugated and altered by human use, she turned to aerial photography and learned to read the stories of the land from the air. The photographs convey her passion for the prairie, and provoke us to consider the ways we use the land.

Revealing Chicago presents a different, though no less beautiful, view of the land we inhabit. The selected photographs demonstrate Evans's ability to contrast the urban fabric of Chicago with the continuous, if at times restrained, presence of nature. Flights made in helicopters, small planes, and hot-air balloons allowed her to shoot from a low elevation and include people in her photographs, and thus show the city being used by its residents. We can see city-dwellers in *North Avenue Beach. Chicago, June 24, 2003*, where the beachgoers cast a pattern of diagonal shadows in the sand surrounding the oval ocean-liner shape of the beach house. Her photograph of Belmont Harbor captures alternating patches of man-made and natural materials, while depicting a group of smelt-catchers in their April tradition of fishing along the banks of Lake Michigan. These human-scaled images invite viewers to consider their lives and decisions in the urban space, while allowing Chicagoans to picture themselves within the iconic images of their beloved city.

Kate O'Neill

WILLIAM GARNETT

William Garnett was inspired by the variety in the American landscape, from the Florida Everglades to the dunes of Death Valley, from New England foliage to hayfields in California. With his inspiration came concern; his philosophies were those of a conservationist. Inspired by his peers in the straight photography movement, Garnett developed a style not unlike that of Ansel Adams and Edward Weston, capturing beautiful subjects with fine detail and focus, and crisp, unmanipulated printing. Garnett's skill as a pilot and an adept airplane mechanic allowed him to fly his 1956 four-passenger Cessna on his photographic excursions.

From his bird's-eye view Garnett could see wild landscape as well as the scars of overdevelopment, air and water pollution, erosion, and deforestation. Rather than photograph the destruction of the environment, though, Garnett preferred to photograph landscapes with the power to inspire. Although he shot

a variety of subjects while on assignment, Garnett often chose to photograph beautiful, extraordinary landscapes, demonstrating his personal philosophy, "To show people the ugly doesn't accomplish much. I came to the conclusion that I can't really make much of a change in society's attitude towards land use by just showing them what is wrong. I've come to the conclusion you have to show them what is right, and inspire them."[1]

Photographs such as *Ploughed Field, Arvin, Calif. (Vertical Aerial, 500 ft.)* (1952) reveal the striking patterns made by the laborious process of turning rows of soil and cutting hay. Contour lines are scraped into the earth by tractor, forming an exquisite pattern of a steep white triangle among a vertical series of stripes, articulated by circles and horizontal lines on the bottom. Agriculture has manipulated the land, and Garnett paints a flat series of lines and circles with his camera, but the aura of the photographs pays homage to the dignity of farming.

In other images Garnett explores the untouched environment. *Nude Dune, Death Valley, Calif. (Vertical Aerial—about 500 ft.)* (1954) is sensuous, yet simultaneously forbidding and lifeless, whereas the rock formation images from Death Valley and Marble Canyon, Arizona, have a peaceful quality though the actual environments are quite severe.

Through his photographs, Garnett quietly asks viewers to appreciate our surroundings and to respect the beauty of the forbidding landscapes, but to leave them be and cultivate lands that resonate with grace.

Sadie Bliss

1. Martha A. Sandweiss, "Introduction," in *William Garnett Aerial Photographs* (Berkeley and Los Angeles: University of California Press, 1994), ix.

MARIO GIACOMELLI

In 1954, after a decade of painting, Mario Giacomelli started photographing his native Italian region of Senigallia from the ground. In a series entitled *On Being Aware of Nature*, Giacomelli created visual effects by using deeply textured black and sharp white contrasts. In 1955, this graphic technique provided a metaphorical language for a series named *The Metamorphosis of the Land*, which focused on his feelings about the cultural legacy of the farmers and the land.

After a plane trip to Bilbao, Spain, in 1970, Giacomelli was inspired to view Senigallia from the air. He began photographing aboard his friend's small crop-dusting plane. In these photographs, he eliminated the horizon and turned the Marche province of Senigallia into a flat canvas of abstract elements. The formal message of his earlier landscapes was replaced with an abstract world of geometric forms, coordinates, and cosmic, interplanetary-looking surfaces.

Giacomelli's themes shifted to poetic thoughts generated by a deep symbiotic relationship with the land. He used a language of ambiguous forms to express an emotional response. His transformations of the land correlate with the emotional language of Abstract Expressionist painting. With his signature charred blacks, brilliant whites, and numerous accentuations, Giacomelli reduced the land to a series of graphic patterns. He reworked his prints to reflect his inner world and emotions, preferring grainy contrasts and overexposed, overdeveloped film. Most importantly, he altered the negatives by cutting or scratching in trees, large blocks of space, and ambiguous marks that provided evidence of his existence.

The majority of the works seen here were taken during the 1970s as part of Giacomelli's series *On Being Aware of Nature*. Exact locations are unknown, and prints are simply labeled *Paesaggio* (Landscape). Instead of highlighting the specificities of the landscape, he reduces the fields to a series of black-and-white patterns that resemble graphite drawings or lithographic prints. Hand-manipulated sections of the prints are virtually indistinguishable from tractor rows in other areas. In much the same graphic patterning that American photographer Aaron Siskind employed in his abstractions, the surfaces of the landscape become pure pattern. Giacomelli continued to work on his aerial photography until 2000. In essence, the land was a springboard for his creative graphic expression.

Christopher Woodhouse

FRANK GOHLKE

Frank Gohlke's aerial photos from the years following the Mount St. Helens eruption in 1981 are unique both within his own work and in contrast to other aerial photographers. His main intention in the Mount St. Helens series is to capture the complicated web of relationships and associations in a specific area. Aerial photography became one important tool to trace regrowth and regeneration in an environment affected by a cataclysmic natural event.

In his search for meaning, Gohlke does not adopt a linear cause-and-effect approach but allows differing factors to play back and forth; each effect of the eruption becomes the unforeseen cause of another tangential experience. Layers

of geological, ecological, economic, and personal meanings become unified layers encoded within the landscape.

As the logical starting point in tracing the life of an area, Gohlke begins his narrative with *Aerial View: Fir and Hardwood Forest Outside Blast Zone. Approximately Twenty Miles from Mount St. Helens* (1981). This unaffected swath of forest depicts what existed before the volcano's eruption. From here Gohlke weaves a story. As he floats above the landscape he memorizes every hill and valley. His photographic record solidifies specific points in time and place, capturing a certain moment that encapsulates the ideas of cyclical destruction and regrowth. His images comment on the effects the volcano had on the human population in the surrounding areas. Lives as well as livelihoods were lost in the eruption. The logging industry suffered setbacks for years to come from the loss at Mount St. Helens. As a visual parallel to the first image of unaffected lumber, undamaged logging areas also show a now-impossible reality for the devastated area surrounding the eruption.

Another image, *Aerial View: Mount St. Helens Rim, Crater, and Lava Dome* (1982), gives a graphic overview of the effects of the blast. New magma rises and creates a new dome that releases smoke through the volcano's vents. A similar view, *Aerial View: Looking South at Mount St. Helens Crater and Lava Dome, Mount Hood and Mount Jefferson in the distance, Airplane in Crater* (1982), frames a tiny airplane below Gohlke's eye, distant enough to look still and small against the dramatic backdrop. Even isolated from the rest of the Mount St. Helens cycle, these aerial shots become a cycle of their own, traveling from unaffected landscape to the genesis of the eruption and beyond. The end connects to the beginning, creating a photographic cycle out of a geological and environmental one.

Mark Binford

EMMET GOWIN

Emmet Gowin views the environmental changes inflicted upon the landscape as one would trace marks of age on the human body. His 2002 project, *Changing the Earth: Aerial Photographs*, documents global environmental ravages caused by recreational, military, and agricultural activities. Rather than repudiating this modernist destruction, however, Gowin treats the wounded land tenderly, exposing the harsh scarring caused by agribusiness, natural resource mining, weapons testing, and toxic waste dumping.

The photographs shown here dwell on two aspects of the American landscape:

irrigation farming and activities at the Nevada Test Site. Center-pivot irrigation, used across the United States to coax crops from nonarable and flat land, consists of multiple segments of connected piping with sprinklers running along their length. Situated on wheeled towers powered by electric motor-driven systems, the spokes move in a circular motion from the central pivot point, from which the water originates. Crops are then planted to conform to this shape. While this practice is monetarily efficient, irrigation pivots deplete natural underlying aquifers and thus cause undeniable changes to the surrounding ecosystem.

The Nevada Test Site, a locale similarly abusive to the land, is an unpopulated region of approximately 5,470 square miles. Only sixty-five miles north of Las Vegas, it currently serves as both a wildlife preserve and a military gunnery range. Other activities include chemical spill testing, conventional weapons testing, waste management, and environmental technology studies. Until 1992, however, the ground was used for more than four decades as a nuclear weapons testing zone. Gowin's *Sedan Crater, Northern End of Yucca Flat, Nevada Test Site* (1996) portrays the consequences of a 1962 explosion that caused a void in the earth 320 feet deep and 1,280 feet across.

Gowin's black-and-white photos, both disturbing and eerily beautiful, allude to a certain absence or loss caused by the physical bereavement of the land. Whether we see it in a barren hole such as the *Sedan Crater* or in the absence of untouched land in *Pivot Irrigation near the One Hundred Circle Farm and the McNary Dam on the Columbia River, Washington* (1991), the photos appear ghostly. The craters in particular allude to moonscapes and uninhabitable land, perhaps warning of a grim future as much as pointing to a marred past.

Gowin develops his prints using bleaching and subtle hand-toning, ranging from metallic grey to smoky red. There is something meditative and even spiritual within the scenes. While he does not extend a call to action as do other environmentalist photographers, he creates a poetic depiction of a *real* place in an *exact* time.

Meghan Sheridan

ADRIEL HEISEY

Adriel Heisey glides over the desert terrain of the American Southwest in his ultra-light plane as he depicts the marks of ancient peoples on the land. He focuses on the human imprint on the landscape, and shows the viewer a hidden beauty: a large boulder, a flock of sheep, an unexcavated village, or footprints in the snow.

In 1991, frustrated with the high speed and confinement of regular planes, Heisey built his own plane, a Kolb Twinstar. The 450-pound aircraft travels between thirty-five and seventy miles per hour, at a low altitude of thirty to six hundred feet. This plane has no other purpose than aerial photography. The engine and propeller are mounted behind the wing, leaving the front end open for unobstructed views. When Heisey photographs, he sits in the open-air cockpit with his feet dangling below him. He rarely uses runways to land his plane, but instead descends onto dirt, gravel, or roads.

Heisey's photographs are complex depictions of the rich Native American archaeological heritage of the Southwest. He emphasizes the importance of ritual in human relationships throughout his work. For instance, kivas and ball courts were two ritual facilities that had to be dug into the earth in order to be constructed. Channeling water into ancient pueblo villages was also necessary for survival in the arid desert land. Often rituals were performed to bring an end to dry spells. Heisey shows marks on the land that speak to these rituals with water.

Heisey also highlights archaeology's relationship to the present. He shows metal towers placed next to ancient ruins and small pueblo sites that are the remains of much larger ancient villages. He photographs positive images of the relationship between the past and present at Paquimé in Chihuahua. In these images, modern fields occupy the same sites as ancient ones. Roads, too, link past and present. Trails and footpaths, the equivalent of modern-day roads, linked ancient communities together. Seen from above, they show the intricate paths that connected ancient people. These major themes in Heisey's work unite his photographs by giving them common attributes, which pictorially describe the history, both past and present, of ancient pueblo sites.

Gioia Brosco

ALEX MACLEAN

It has been over thirty years since aerial photographer Alex MacLean turned to the sky to explore the American landscape through a different perspective. In 1975, two years after receiving his Master of Architecture degree from the Graduate School of Design at Harvard University, he earned his commercial pilot's license and founded his own company, Landslides, which specializes in aerial photography. In his vintage 1967 Cessna 182 single-engine plane, MacLean is both the pilot and the artist, circling his subjects as if they are prey. Manipulating the angle and altitude of his plane, he controls light and atmosphere to create crisp, geometric compositions. Flying at altitudes of around one to two thousand feet, he uses his knowledge of urban planning and architecture to capture unique images that describe the land below. His architectural training and artistic talent allow him not only to photograph striking colors and compositions, but also to ensure that the images can be used as tools by engineers, planners, architects, and environmentalists in tackling issues of urban sprawl, preservation, and pollution.

The images selected for *To Fly* demonstrate MacLean's variety of subjects, while consistently focusing on the patterns and borders man introduces to the land. Since the introduction of the 1785 Land Ordinance, patterns and grids have marked the American landscape and defined its boundaries and industries. Most importantly, patterns are the result of man's use of the land: proof of an ever-changing cultural landscape that has been, and continues to be, shaped by humans.

In these images, we see the formal patterns created by row housing in Somerville, Massachusetts, the radial patterns of a railroad turntable, and the contrasting undulating forms of green and gold crop rows. MacLean addresses graphic issues in a wide variety of landscapes across the continent—urban, industrial, and agricultural. His work includes both formal geometric patterning and a thoughtful commentary on land-use issues.

One cannot see the repetitious and abstract look of these calculated pathways and containments from the ground. It is only from above, often at a close oblique angle, that they become eerily similar in design and function across the whole of the nation. MacLean forces us to recognize the changes we have made on the land, but does not necessarily provoke guilt about our choices. Rather, he creates awareness about the issues of conservation and change.

Alyssa Spadoni

DAVID MAISEL

David Maisel captures the vivid abstract geometry of environmentally contentious sites in his aerial photographs of the American West. He seeks out areas of the world where land merges in entropic descent. His earliest work with *Black Maps* examined the geometry of mining sites from above, and his discovery of the fluorescent colors produced by their inherent chemicals is the signature of this more recent project. Engaging the space between aesthetics and ethics, Maisel illuminates his concern for the land while at the same time masking factual information through abstraction.

In 2001, Maisel began *The Lake Project*, a series of flights over the dry bed of Owens Lake between the Sierra Nevada and Inyo Mountains in California. A controversial site, Owens Lake was drained in 1913 to meet the rising need for water in the burgeoning city of Los Angeles. The dry lakebed contains the highest levels of particulate matter pollution in North America and caused debilitating dust storms until the Los Angeles Department of Water and Power was sued to reirrigate the plain. Maisel's photographs from *The Lake Project* present pictures from before and after this flooding, but instead of emphasizing positive change, they exaggerate geometry and color. The pictures resemble a desiccated corpse with blood-red veins: a phenomenon caused by salt-eating bacteria. The images are abstract and beautiful, and the land below is not easily identifiable. In contrast to Landsat photographs of the area, Maisel's photographs are cropped and framed to offer almost no visual clues of direction, horizon, or surrounding land. Shot from roughly 13,000 feet, they are maps of Maisel's experience over the lake, and when viewed in a series, they offer more information about his reaction than about the lake itself. Titled by number and unidentified, the pictures force the viewer to come face-to-face with the sublime without knowing what he or she is seeing. Maisel recounts his travels in the airplane in a stream-of-consciousness essay that accompanies the catalog. This information further attests to his desire to create art photographs, more reminiscent of abstract painting than life.

Maisel offers no explanatory information with his photographs, and they emphasize art rather than document. Although historically photographs have been viewed as scientific witnesses to the events and facts of the world, these images reveal the abstract and selective view that an artist creates to emphasize the photograph as artifice. Maisel seeks to emphasize the camera as a tool of art, and in turn his aerial process is part of that whole.

Lisa Sutcliffe

SOPHIE RISTELHUEBER

Sophie Ristelhueber's *FAIT* series (1992)—a compelling and lyrical commentary of the first Iraq War—is the most overtly political project in this study. Ristelhueber takes as her subject a specific war at a specific moment in history. *FAIT* is a multiple work. A compilation of seventy-one aerial and ground images—each printed in a 40x50-inch format and mounted together in an installation—its form recalls the typologies of Bernd and Hilla Becher. Only two of the panels are presented here. *FAIT* is the only instance of aerial photography in the French artist's career.

Ristelhueber was inspired for this project by a 1991 photograph of the Kuwait desert in *Time* magazine (February 25, 1991). It reminded her of *Dust Breeding*, Marcel Duchamp's photographic record of his *Large Glass*. She traveled in Kuwait for several weeks, seven months after the end of the war. These are not battlefield photographs, despite the long tradition of aerial photographs for military purposes. Instead, they are maps of a kind of archaeological ruin, haunting records of the detritus left in the shifting sands at the end of a war. Ristelhueber made some of her images from the air, finding—with difficulty—various helicopters and airplanes to ride in. Leaning out of the aircraft doors, she had a specific view of what she wanted to capture.

FAIT consists of both color and black-and-white images, and a number are not aerial views; Ristelhueber also walked in the desert among the debris, recording clothes, vehicle tracks, old shells, and shaving brushes, feeling a need to "locate the humanity within such violence" as well as recording it from above.[1] The photographs are mounted on boxes rimmed in three shades of gold. The artist describes the installation as a series of boxes that are "at once precious and much like camouflage."[2] The finished installation was shown in its entirety in Grenoble and at the Albright Knox Art Gallery in Buffalo, and was published as a small book as well.

These photographs record death rather than life: they differ markedly from the distanced view in the rest of the exhibition. One shows a line of derailed trains in the desert, creating a seemingly bloody red line of fractured rectangles, half-covered with sand. Another presents shapes that are completely covered by the shifting sands.

Kim Sichel

1. Cheryl Brutvan, *Sophie Ristelhueber: Details of the World* (Boston: MFA Publications, 2001), 137.
2. Ann Hindry, *Sophie Ristelhueber* (Paris: Editions Hazan, 1998), 60.

BRADFORD WASHBURN

Bradford Washburn's name is synonymous with Mount McKinley. After his first climb up Mount Washington in New Hampshire's White Mountains at age eleven, he was captivated—and thus began a lifelong career among the world's highest peaks. Washburn was the first to summit some of Alaska's most well-known peaks, including Mount Crillon in 1934 and Mount Dickey in 1955. Most notable, however, are Washburn's expeditions up Mount McKinley: he reached its summit three times, in 1942, 1947, and 1951. In 1947 his wife Barbara accompanied him, the first woman to climb McKinley.

To an aerial photographer, McKinley seems an ideal subject, and Washburn produced thousands of images that capture the dramatic contrast of light and shadow amongst the peaks, as well as stunning, abstracted views of the patterns and textures of the Alaskan glaciers. He has always identified himself as a scientist, rather than an artist, yet it is difficult to look at his McKinley images without seeing them as works of art.

Washburn took his first aerial photographs in 1927, during a flight over Mont Blanc, and made his first flights over Mount McKinley in 1936 and again in 1938, on assignment for the National Geographic Society. His aerial views of the mountain have proven indispensable in mapping the topography of the area; an updated map was published in 1960—a result of his three expeditions to the summit as well as numerous photographic surveying flights. The route he mapped during the 1951 expedition up its West Buttress remains the fastest and safest route for climbers today.

These photographs represent a broad cross-section of Washburn's numerous flights over Mount McKinley. The earliest images seen here were made in 1938, and the latest come from one of his final aerial surveys of the mountain in 1978. In treading the fine line between mapping and fine art, each of these photographs represents "uncharted" territory from his viewpoint, but also technical mastery of a difficult aerial process. His ability to capture a windstorm sweeping across McKinley's peaks, a glacier at twilight, or a sunset over the West Face of the mountain at 41,000 feet, attests to an eye that extends beyond a topographical map.

Boston Museum of Fine Arts curator Clifford Ackley has aptly summarized the complicated relationship between science and art in Washburn's photographs, stating, "Perhaps the central visual message of Washburn's aerial photographs is the revelation of how the earth works. This is at once good science and expressive art."[1] Washburn has created a notable place for himself as a bridge between the two.

Jessica Roscio

1. Clifford Ackley, *View from Above: The Photographs of Bradford Washburn.* www.mfa.org/exhibitions/sub.asp?key=15&subkey=612

EXHIBITION CHECKLIST

Olivo Barbieri
site specific_LAS VEGAS 05, 2005
C-print, 48 x 68 in.
Courtesy of Yancey Richardson Gallery, New York, NY

Olivo Barbieri
site specific_LAS VEGAS 05, 2005
C-print, 48 x 68 in.
Courtesy of Yancey Richardson Gallery, New York, NY

Barbara Bosworth
Untitled Aerial View from the series *Rising*, 2000
Gelatin silver print, 20 x 24 in.
Courtesy of the artist

Barbara Bosworth
Untitled Aerial View from the series *Rising*, 2000
Gelatin silver print, 20 x 24 in.
Courtesy of the artist

Barbara Bosworth
Untitled Aerial View from the series *Rising*, 2003
Gelatin silver print, 20 x 24 in.
Courtesy of the artist

Barbara Bosworth
Untitled Aerial View from the series *Rising*, 2001
Gelatin silver print, 20 x 24 in.
Courtesy of the artist

Marilyn Bridges
Pyramid of Khephren, Giza, 1993
Gelatin silver print, 24 x 20 in.
Courtesy of the artist

Marilyn Bridges
Stepped Pyramid of Djoser with Shadow, Saqqara, 1993
Gelatin silver print, 20 x 24 in.
Courtesy of the artist

Marilyn Bridges
The Pyramids of Giza with Cairo, 1993
Gelatin silver print, 20 x 24 in.
Courtesy of the artist

Marilyn Bridges
Temple of Khons, Karnak, 1993
Gelatin silver print, 20 x 24 in.
Courtesy of the artist

Esteban Pastorino Díaz
Belanio, Skopelos, Greece, 2002
C-print, 16 x 20 in.
Courtesy of PDNB Gallery, Dallas, TX

Esteban Pastorino Díaz
Village, Skopelos, Greece, 2002
C-print, 16 x 20 in.
Courtesy of PDNB Gallery, Dallas, TX

Esteban Pastorino Díaz
Camiones en Cantera, Skopelos, Greece, 2002
C-print, 16 x 20 in.
Courtesy of PDNB Gallery, Dallas, TX

Esteban Pastorino Díaz
ΔHMAPXEION, Skopelos, Greece, 2002
C-print, 16 x 20 in.
Courtesy of PDNB Gallery, Dallas, TX

Terry Evans
Jetty. Lakefront Near Downtown, Chicago, January 29, 2004
Archival digital print, 19 x 19 in.
Courtesy of Catherine Edelman Gallery, Chicago, IL

Terry Evans
Smelt Season. Belmont Harbor, Chicago, April 23, 2004
Archival digital print, 19 x 19 in.
Courtesy of Catherine Edelman Gallery, Chicago, IL

Terry Evans
North Avenue Beach. Chicago, June 24, 2003
Archival digital print, 19 x 19 in.
Courtesy of Catherine Edelman Gallery, Chicago, IL

Terry Evans
Oak Street Beach. Chicago, April 27, 2004
Archival digital print, 19 x 19 in.
Courtesy of Catherine Edelman Gallery, Chicago, IL

William Garnett
Ploughed Field, Arvin, Calif. (Vertical Aerial, 500 ft.), 1952
Gelatin silver print, 18 x 14½ in.
© William A. Garnett
Courtesy of Polaroid Collections, Waltham, MA

William Garnett
Nude Dune, Death Valley, Calif. (Vertical Aerial, about 500 ft.), 1954
Gelatin silver print, 18 x 15 in.
© William A. Garnett
Courtesy of Polaroid Collections, Waltham, MA

William Garnett
Hill Projecting Through Alluvial Fan, Death Valley, Calif. (Oblique Aerial), 1953
Gelatin silver print, 18 x 15 in.
© William A. Garnett
Courtesy of Polaroid Collections, Waltham, MA

William Garnett
Butte, Marble Canyon, Arizona (Vertical Aerial, 1000 ft.), 1954
Gelatin silver print, 18 x 15 in.
© William A. Garnett
Courtesy of Polaroid Collections, Waltham, MA

Mario Giacomelli
Paesaggio 408, 1970s
Gelatin silver print, 12 x 16 in.
Courtesy of Robert Klein Gallery, Boston, MA

Mario Giacomelli
Paesaggio 290, 1976
Gelatin silver print, 12 x 16 in.
Courtesy of Robert Klein Gallery, Boston, MA

Mario Giacomelli
Paesaggio 288, 1970
Gelatin silver print, 12 x 16 in.
Courtesy of Robert Klein Gallery, Boston, MA

Frank Gohlke
Aerial View: Fir and Hardwood Forest Outside Blast Zone. Approximately Twenty Miles from Mount St. Helens, 1981
Gelatin silver print, 30 x 40 in.
Courtesy of the artist

Frank Gohlke
Aerial View: Looking South at Mount St. Helens Crater and Lava Dome, Mount Hood and Mount Jefferson in the Distance, Airplane in Crater, 1982
Gelatin silver print, 30 x 40 in.
Courtesy of the artist

Frank Gohlke
Aerial View: Mount St. Helens Rim, Crater, and Lava Dome, 1982
Gelatin silver print, 30 x 40 in.
Courtesy of the artist

EXHIBITION CHECKLIST

Olivo Barbieri
site specific_LAS VEGAS 05, 2005
C-print, 48 x 68 in.
Courtesy of Yancey Richardson Gallery, New York, NY

Olivo Barbieri
site specific_LAS VEGAS 05, 2005
C-print, 48 x 68 in.
Courtesy of Yancey Richardson Gallery, New York, NY

Barbara Bosworth
Untitled Aerial View from the series *Rising*, 2000
Gelatin silver print, 20 x 24 in.
Courtesy of the artist

Barbara Bosworth
Untitled Aerial View from the series *Rising*, 2000
Gelatin silver print, 20 x 24 in.
Courtesy of the artist

Barbara Bosworth
Untitled Aerial View from the series *Rising*, 2003
Gelatin silver print, 20 x 24 in.
Courtesy of the artist

Barbara Bosworth
Untitled Aerial View from the series *Rising*, 2001
Gelatin silver print, 20 x 24 in.
Courtesy of the artist

Marilyn Bridges
Pyramid of Khephren, Giza, 1993
Gelatin silver print, 24 x 20 in.
Courtesy of the artist

Marilyn Bridges
Stepped Pyramid of Djoser with Shadow, Saqqara, 1993
Gelatin silver print, 20 x 24 in.
Courtesy of the artist

Marilyn Bridges
The Pyramids of Giza with Cairo, 1993
Gelatin silver print, 20 x 24 in.
Courtesy of the artist

Marilyn Bridges
Temple of Khons, Karnak, 1993
Gelatin silver print, 20 x 24 in.
Courtesy of the artist

Esteban Pastorino Díaz
Belanio, Skopelos, Greece, 2002
C-print, 16 x 20 in.
Courtesy of PDNB Gallery, Dallas, TX

Esteban Pastorino Díaz
Village, Skopelos, Greece, 2002
C-print, 16 x 20 in.
Courtesy of PDNB Gallery, Dallas, TX

Esteban Pastorino Díaz
Camiones en Cantera, Skopelos, Greece, 2002
C-print, 16 x 20 in.
Courtesy of PDNB Gallery, Dallas, TX

Esteban Pastorino Díaz
ΔHMAPXEION, Skopelos, Greece, 2002
C-print, 16 x 20 in.
Courtesy of PDNB Gallery, Dallas, TX

Terry Evans
Jetty. Lakefront Near Downtown, Chicago, January 29, 2004
Archival digital print, 19 x 19 in.
Courtesy of Catherine Edelman Gallery, Chicago, IL

Terry Evans
Smelt Season. Belmont Harbor, Chicago, April 23, 2004
Archival digital print, 19 x 19 in.
Courtesy of Catherine Edelman Gallery, Chicago, IL

Terry Evans
North Avenue Beach. Chicago, June 24, 2003
Archival digital print, 19 x 19 in.
Courtesy of Catherine Edelman Gallery, Chicago, IL

Terry Evans
Oak Street Beach. Chicago, April 27, 2004
Archival digital print, 19 x 19 in.
Courtesy of Catherine Edelman Gallery, Chicago, IL

William Garnett
Ploughed Field, Arvin, Calif. (Vertical Aerial, 500 ft.), 1952
Gelatin silver print, 18 x 14½ in.
© William A. Garnett
Courtesy of Polaroid Collections, Waltham, MA

William Garnett
Nude Dune, Death Valley, Calif. (Vertical Aerial, about 500 ft.), 1954
Gelatin silver print, 18 x 15 in.
© William A. Garnett
Courtesy of Polaroid Collections, Waltham, MA

William Garnett
Hill Projecting Through Alluvial Fan, Death Valley, Calif. (Oblique Aerial), 1953
Gelatin silver print, 18 x 15 in.
© William A. Garnett
Courtesy of Polaroid Collections, Waltham, MA

William Garnett
Butte, Marble Canyon, Arizona (Vertical Aerial, 1000 ft.), 1954
Gelatin silver print, 18 x 15 in.
© William A. Garnett
Courtesy of Polaroid Collections, Waltham, MA

Mario Giacomelli
Paesaggio 408, 1970s
Gelatin silver print, 12 x 16 in.
Courtesy of Robert Klein Gallery, Boston, MA

Mario Giacomelli
Paesaggio 290, 1976
Gelatin silver print, 12 x 16 in.
Courtesy of Robert Klein Gallery, Boston, MA

Mario Giacomelli
Paesaggio 288, 1970
Gelatin silver print, 12 x 16 in.
Courtesy of Robert Klein Gallery, Boston, MA

Frank Gohlke
Aerial View: Fir and Hardwood Forest Outside Blast Zone. Approximately Twenty Miles from Mount St. Helens, 1981
Gelatin silver print, 30 x 40 in.
Courtesy of the artist

Frank Gohlke
Aerial View: Looking South at Mount St. Helens Crater and Lava Dome, Mount Hood and Mount Jefferson in the Distance, Airplane in Crater, 1982
Gelatin silver print, 30 x 40 in.
Courtesy of the artist

Frank Gohlke
Aerial View: Mount St. Helens Rim, Crater, and Lava Dome, 1982
Gelatin silver print, 30 x 40 in.
Courtesy of the artist

Emmet Gowin
*Pivot Irrigation Near the One Hundred Circle Farm and the McNary
Dam on the Columbia River, Washington*, 1991
Toned gelatin silver print, 14 x 11 in.
Courtesy of the artist

Emmet Gowin
*The Buffalo Jump Called Chugwater and an Irrigation Pivot Near
Wheatland, Wyoming*, 1991
Toned gelatin silver print, 14 x 11 in.
Courtesy of the artist

Emmet Gowin
Snow Over Pivot Agriculture near Liberal, Kansas, 1995
Toned gelatin silver print, 14 x 11 in.
Courtesy of the artist

Emmet Gowin
Sedan Crater, Northern End of Yucca Flat, Nevada Test Site, 1996
Toned gelatin silver print, 14 x 11 in.
Courtesy of the artist

Adriel Heisey
*Roomblocks with Reconstructed Adobe Walls, Central Complex,
Paquimé, Casas Grandes, Chihuahua, Mexico*, 2000
C-print, 32 x 24 in.
Courtesy of the artist

Adriel Heisey
*Sinagua Village with Tailings Pond, Tuzigoot National Monument,
Verde River Valley, Arizona*, 1998
C-print, 24 x 30 in.
Courtesy of the artist

Adriel Heisey
*Pueblo Room Blocks in Snow, Puyé Pueblo, Santa Clara Indian
Reservation, New Mexico*, 2001
C-print, 24 x 32 in.
Courtesy of the artist

Adriel Heisey
Serpent Intaglio with Palo Verde, Arizona, 2000
C-print, 24 x 32 in.
Courtesy of the artist

Alex MacLean
Two-Family Houses in Streetcar Community, Somerville, Massachusetts, 1983
C-print, 24 x 36 in.
Courtesy of the artist

Alex MacLean
Railroad Turntable, Minneapolis, Minnesota, 1985
C-print, 24 x 36 in.
Courtesy of the artist

Alex MacLean
Dryland Farming Field Near Shelby, Montana, 1991
C-print, 24 x 36 in.
Courtesy of the artist

David Maisel
The Lake Project #2, 2001-2003
C-print, 29 x 29 in.
Courtesy of the artist and Miller Block Gallery, Boston, MA

David Maisel
The Lake Project #16, 2001-2003
C-print, 29 x 29 in.
Courtesy of the artist and Miller Block Gallery, Boston, MA

Bradford Washburn
Windstorm, Mount McKinley, Alaska, 1942
Gelatin silver print, 16 x 20 in.
Courtesy of Panopticon Gallery, Boston, MA

Bradford Washburn
Karstens Ridge, Mount McKinley, Alaska, 1966
Gelatin silver print, 16 x 20 in.
Courtesy of Panopticon Gallery, Boston, MA

Bradford Washburn
Windstorm, Muldrow Glacier, Alaska, 1947
Gelatin silver print, 16 x 20 in.
Courtesy of Panopticon Gallery, Boston, MA

Bradford Washburn
Sunset at 41,000 feet, Mount McKinley, Alaska, 1978
Gelatin silver print, 16 x 20 in.
Courtesy of Panopticon Gallery, Boston, MA

NASA
Earthrise–Apollo 8 (William Anders), 1968
Laser print, 20 x 20 in.
Courtesy of Polaroid Collections, Waltham, MA

NASA
View of India and Ceylon as seen from Gemini 11 Spacecraft (Richard Gordon), 1966
Laser print, 18 x 20 in.
Courtesy of Polaroid Collections, Waltham, MA

Landsat 5
Image of the Luxor Region, Egypt, 1986
Inkjet print from false-color digital source, 36 x 40 in.
Courtesy of Center for Remote Sensing, Boston University

BIOGRAPHIES & BIBLIOGRAPHY, *Edited by Ginger Elliott Smith*

OLIVO BARBIERI

Born in Capri in 1954, Italian photographer Olivo Barbieri began exhibiting his photographs in 1978, capturing the urban spaces of cities across Europe and Asia. He has exhibited at the Folkwang Museum, Germany; the Center for Canadian Architecture in Montreal, and the Italian Institute of Culture in Lille, France, and participated in the Venice Biennale in 1993, 1995, and 1997. He turned to aerial photography in 2003, beginning with films and still images of Rome.

Barbieri, Olivo. *Olivo Barbieri: Artificial Illuminations*. Washington, DC: Smithsonian Institution Press, 1998.

____. *Cityscape/Landscape*. Milan: Silvana Editoriale, Cinisello Balsamo, 2002.

____. *Fotografien seit 1978*. Essen: Museum Folkwang, 1996.

____. *site specific_LAS VEGAS*. Toronto: Wonder, Inc, 2005.

____. *site specific_ROMA*. Rome: Zone Attive Edizioni, 2004.

Lortie, André, ed. *The 60s: Montreal Thinks Big*. Montreal: Canadian Centre for Architecture, 2004.

BARBARA BOSWORTH

Barbara Bosworth, born in Cleveland, Ohio, in 1953, graduated from Bowling Green State University and went on to earn her MFA in photography from the Rochester Institute of Technology in 1983. Since 1984, Bosworth has served as Professor of Photography at Massachusetts College of Art in Boston. Her most notable honors include the Guggenheim and New England Foundation for the Arts fellowships and a Buhl Foundation grant, as well as over twenty-five exhibitions and nearly twenty publications. Bosworth currently lives in Stowe, Massachusetts.

Bang! The Gun As Image. Tallahassee: Museum of Fine Arts, Florida State University, 1997.

Bosworth, Barbara. *Trees: National Champions*. Essays by John Stilgoe and Doug Nickel. Cambridge, MA, and London: MIT Press, 2005.

Barbara Bosworth. Princeton, NJ: The Art Museum, Princeton University, 2000. Exhibition catalog.

Centric 29: Barbara Bosworth. Essay by Sheryl Conkleton. Long Beach, CA: University Art Museum, California State University, 1987.

MARILYN BRIDGES

Marilyn Bridges was born in New Jersey in 1948. From 1967 to 1975, Bridges studied at the Art Students League and took photographs for airline and women's magazines. In 1976, she took her first color aerial photographs of the Nazca line drawings, and switched to black and white immediately thereafter. Bridges has had solo exhibitions at the International Center of Photography, National Arts Club, Columbus Museum of Art, Musée de la photographie, Charleroi, Belgium, American Museum of Natural History, and many other museums. Bridges has earned both Guggenheim and Fulbright grants and in 2003 the Wings Trust Award, which honors significant women explorers.

Bacardi Art Gallery. *The Nazca Lines: A Photographic Essay*. Miami, FL: Bacardi Art Gallery, 1987.

Bridges, Marilyn. *Egypt: Antiquities from Above*. Essay by Penelope Lively. Boston: Little Brown and Co., 1996.

____. *Markings: Aerial Views of Sacred Landscapes*. Preface by Haven O'More, essays by Maria Reiche, Charles Gallencamp, Lucy Lippard, and Keith Critchlow. New York: Aperture, 1986.

____. *Planet Peru*. New York: Aperture, 1991.

____. *The Sacred & Secular: A Decade of Aerial Photography*. Essay by Vicki Goldberg. Interview by Anne Hoy. New York: International Center of Photography, 1990.

____. *This Land Is Your Land: Across America by Air*. Essay by William Least Heat-Moon. New York: Aperture, 1997.

Goldberg, Vicki. "An Intimacy with the Land: The Aerial Photography of
 Marilyn Bridges." *Archaeology* 44 (November/December, 1991): 32–39.

ESTEBAN PASTORINO DÍAZ

*Argentinean photographer Esteban Pastorino Díaz was born in Buenos Aires in 1972 and
initially pursued a technical education in mechanical engineering. He changed his professional
course dramatically when, in 1995, he enrolled in an advertisement photography program at
Fotodesign in Buenos Aires. Since then, he has continued to make photographs, holding his
first solo exhibition in 1997. From 2001 to 2005 Pastorino Díaz focused solely on his aerial
photographic series. He is currently an Artist in Residence at Casa de Velazquez in Madrid,
Spain.*

Castro, Fernando. "Esteban Pastorino: Photographs Do Not Bend Gallery."
 Art Lies (Winter 2005): 88.
Castro, Fernando. "Esteban Pastorino Díaz: a View from Somewhere."
 Aperture 181 (Fall 2005): 54–65.
Daniel, Mike. "Esteban Pastorino Díaz at Photographs Do Not Bend." *Dallas
 News*, 24 (September 2004).

TERRY EVANS

*Born in 1944 in Kansas City, Missouri, Terry Evans grew up in the heart of the American
prairie. She pursued a BFA in painting and commercial art at the University of Kansas and
spent most of her adult life in Salina, Kansas, before moving to Chicago. Evans has been
the recipient of several prestigious grants, including the National Endowment for the Arts,
the Kansas Committee for the Humanities, and the John Simon Guggenheim Memorial
Fellowship, among others. She continues to live and work in Chicago.*

Enyeart, James, Terry Evans, and Larry Schwarm. *No Mountains in the Way, Kansas
 Survey: NEA.* Lawrence, KS: University of Kansas Museum of Art, 1975.
Evans, Terry. *Disarming the Prairie.* Baltimore: The Johns Hopkins University
 Press, 1998.
____. *The Inhabited Prairie.* Lawrence, KS: The University of Kansas Press, 1998.
____. *Prairie: Images of Ground and Sky.* Lawrence, KS: The University of Kansas
 Press, 1986.
____. *Revealing Chicago: An Aerial Portrait.* New York: Harry N. Abrams, Inc.,
 2005.

WILLIAM GARNETT

*William Garnett, born in Chicago in 1916, attended the Art Center School of Los Angeles
in the 1930s. During a cross-country flight following his 1945 discharge from the U.S.
Army, he decided to pursue aerial photography. In 1953 Garnett received his first of three
Guggenheim grants—the first aerial photographer to receive the award—then exhibited
photographs in the Family of Man exhibition at the Museum of Modern Art, and had a first
solo exhibition in 1955 at the International Museum of Photography in Rochester. Nearly
fifty group and solo exhibitions of his work followed. From 1968 to 1984, Garnett taught
photography at the College of Environmental Design, University of California, Berkeley.
He died on August 26, 2006, at his home in Napa, California.*

Garnett, William. *The Extraordinary Landscape: Aerial Photographs of America.*
 Boston: Little Brown, 1982.
____. *William Garnett: Aerial Photographs.* Essay by Martha Sandweiss. Berkeley:
 University of California Press, 1994.
Owings, Nathaniel Alexander. *The American Aesthetic.* New York: Harper &
 Row, 1969.
Park, Edwards. "The Eye of Bill Garnett Looks Down on the Commonplace
 and Sees Art," *Smithsonian* (May 1977): 74–81.
Plagens, Peter. "William Garnett: A View from Above," *Aperture* 85 (1981):
 22–33.

MARIO GIACOMELLI

*Born in 1925 in Senigallia, Italy, Mario Giacomelli spent his entire life working within a
concentrated radius of his small hometown. He left high school at 13 to become an apprentice
of typography, subsequently pursuing poetry and painting. In 1952 he purchased his first
camera, and began studying under Giuseppe Cavalli two years later. Best known for his
aerial photography of pastoral landscapes, Giacomelli routinely "drew" in the land with a
tractor and captured his work from the air aboard his friend's small crop-dusting airplane.
He died in 2000.*

Brigidi, Stephen, and Claire V.C. Peeps. *Mario Giacomelli.* Carmel, CA: The
 Friends of Photography, 1983.
Carli, Enzo. *Mario Giacomelli, La forma dentro, fotographie 1952–1995.*
 Milan: Charta, 1995.
Celant, Germano, ed. *Mario Giacomelli.* Milan: Photology; Modena:
 Distribuzione Logos, 2001.

___. *Mario Giacomelli: A Retrospective 1955–1983*. ffotogallery, Cardiff. Aberystwyth: University of Wales, 1983.

Crawford, Alistair. "For Mario Giacomelli," *Mario Giacomelli*. London: Phaidon, 2001.

Genovali, Sandro. *Mario Giacomelli, Evoking Shadow*. Milan: Charta, 2002.

Lion, M., ed. *Mario Giacomelli. La Terra, la Materia. Visioni di Calabria*. Catanzaro: Abramo Ed., 1996.

Steinorth, Karl, ed. *Mario Giacomelli. Fotografie 1952–1995*. Museum Ludwig, Cantz: Ostfildern, 1995.

FRANK GOHLKE

Frank Gohlke was born in 1942 in Wichita Falls, Texas. He earned his BA from the University of Texas, Austin, before pursuing an MA degree in English at Yale University. Gohlke received a Guggenheim Fellowship in 1975 for his Grain Elevator series. He has had solo exhibitions at the International Museum of Photography, Rochester; Museum of Modern Art, New York; and Cleveland Museum of Art. Gohlke began photographing Mount St. Helens after its 1980 volcanic eruption.

Frank Gohlke: Landscapes from the Middle of the World. Photographs 1972–1987. Introduction by Ben Lifson. San Francisco: the Friends of Photography, and Chicago: The Museum of Contemporary Photography, 1988.

Gohlke, Frank. *Measures of Emptiness, Grain Elevators in the American Landscape*. With an essay by John C. Hudson. Baltimore, London: The Johns Hopkins University Press, 1992.

___. "A Volatile Core," *Aperture* 98 (1985): 28–29.

___. "Thoughts on Landscape," *Landscape Journal* 14 (1995): 1–9.

___. *Mount St. Helens*. Introduction by Peter Galassi, essays by Kerry Sieh and Simon LeVay. New York: Museum of Modern Art, 2005.

Kelley, Margot Anne. *Local Treasures: Geocaching Across America*. Foreword by Frank Gohlke. Placitas, New Mexico: Center for American Places, 2006.

Lafo, Rachel Rosenfeld et al. *The Sudbury River: A Celebration*. Lincoln, MA: De Cordova Museum and Sculpture Park, 1993.

New Topographics: Photographs of a Man-altered Landscape (Robert Adams – Lewis Baltz – Bernd and Hilla Becher – Joe Deal – Frank Gohlke – Nicholas Nixon – John Schott – Stephen Shore – Henry Wessel, Jr.). Introduction by William Jenkins. Rochester, NY: International Museum of Photography, 1975.

Sichel, Kim. *Icon to Irony*. With additional essays by Judith Bookbinder and John Stomberg. Boston: Boston University Art Gallery, 1995.

EMMET GOWIN

Emmet Gowin was born in Danville, Virginia, in 1941, and studied business at Danville Technical Institute. By 1965, he had earned a BFA in Graphic Design and enrolled in the Rhode Island School of Design in the MFA Photography program. In 1975 and 1977 he was awarded Guggenheim and National Endowment for the Arts fellowships respectively. Since 1973, Gowin has been a photography professor at Princeton University.

Bunnell, Peter C. *Gowin: Photographs, 1966–1983*: Washington, D.C.: Corcoran Gallery of Art, 1983.

Chahroudi, Martha. *Emmet Gowin: Photographs, This Vegetable Earth is But a Shadow*. Philadelphia: Philadelphia Museum of Art in association with Bulfinch Press, 1990.

Gowin, Emmet. *Emmet Gowin: Photographs*. New York: Alfred A. Knopf, Inc., 1976.

___. *Private Realities: Recent American Photography*, exhibition catalogue. Boston: Museum of Fine Arts, 1974.

Reynolds, Jock. *Emmet Gowin: Changing the Earth, Aerial Photographs*. New Haven: Yale University Press, 2002.

ADRIEL HEISEY

Adriel Heisey, born in Harrisburg, Pennsylvania, in 1957, began flying at the age of 15. By his early twenties he became a Certified Flight Instructor, while concurrently pursuing his interest in photography. In 1990 Heisey engineered a plane specifically designed to enable the aerial photography he wanted to accomplish. With over 9,000 flying hours under his belt, he has explored and captured images of the archaeology of the Four Corners region. Heisey continues to live and work in Colorado.

Heisey, Adriel. *From Above: Images of a Storied Land*. Albuquerque, NM: The Albuquerque Museum, 2004.

Heisey, Adriel. *Under the Sun: A Sonoran Desert Odyssey.* Tucson: Rio Nuevo Publishers, 2000.

Heisey, Adriel, and Kenji Kawano. *In the Fifth World: Portrait of the Navajo Nation.* Tucson, AZ: Rio Nuevo Publishers, 2001.

Schuab, Grace. "Interview with Adriel Heisey, Aerial Photographer." *Photographer's Forum* 9 (Spring 2001): 46–55.

The Albuquerque Museum. *From Above: Images of a Storied Land, Photographs by Adriel Heisey,* exhibition catalog. Albuquerque, NM, and Tucson, AZ: The Albuquerque Museum and the Center for Desert Archaeology, 2004.

ALEX MACLEAN

Born in 1947 in Seattle, Alex MacLean earned a Master of Architecture from Harvard University's Graduate School of Design in 1973, which began the trajectory for his career as an aerial photographer. In 1975, he obtained a commercial pilot's license in order to facilitate a graduate study on community planning in which he was involved; he has been making aerial photographs ever since. MacLean has been the recipient of two grants from the National Endowment for the Arts, in 1980 and 1990, and currently lives and works in the Boston area.

Campoli, Julie, Elizabeth Humstone, and Alex MacLean. *Above and Beyond: Visualizing Change in Small Towns and Rural Areas.* Chicago: Planners Press, 2002.

Corner, James, and Alex S. MacLean. *Taking Measures Across the American Landscape.* New Haven: Yale University Press, 1996.

MacLean, Alex S. *Air lines: Photographs.* Salem, MA: Peabody Essex Museum, 2005.

MacLean, Alex S., and Bill McKibben. *Look at the Land: Aerial Reflections on America.* New York: Rizzoli, 1993.

MacLean, Alex S., James Corner, Gilles A. Tiberghien, and Jean-Marc Besse. *Designs on the Land: Exploring America from the Air.* New York: Thames and Hudson, 2003.

DAVID MAISEL

Born in 1961 in New York City, David Maisel studied under Emmet Gowin at Princeton University and made his first aerial expedition with Gowin in 1983 by flying over Mount St. Helens. Maisel graduated from Harvard University's Graduate School of Design in 1989 and won a National Endowment for the Arts Visual Arts Fellowship the following year. Since then he has participated in sixteen solo and group exhibitions and published The Lake Project *in 2004. Maisel is currently based in the San Francisco Bay area.*

Gaston, Diana. "Immaculate Destruction: David Maisel's *Lake Project.*" *Aperture* (Fall 2003).

Hoffman, Abraham. *Vision or Villainy: Origins of the Owens Valley–Los Angeles Water Controversy.* College Station, TX: Texas A & M University Press, 1981.

Maisel, David. http://www.lakeproject.org

____. "Oblivion." *Daylight Magazine* (Fall 2004).

____. "Unraveling Smithson: Some Thoughts and Considerations Regarding Robert Smithson's Art and Writings and Their Effect and Influence on My Own Art Practice." http://www.davidmaisel.com

Olson, Marisa. "The Abstract Aerial Landscape Photography of David Maisel." *Camera Arts* (April/May 2003).

Sobieszek, Robert and David Maisel. *The Lake Project.* Nazraeli Press, 2004.

Tucker, Anne, and David Maisel. *Terminal Mirage.* China: Oceanic Graphic Printing, 2005.

SOPHIE RISTELHUEBER

Born in 1949 in Paris, Sophie Ristelhueber studied at the Sorbonne and École Pratique des Hautes Études. She worked in publishing until, in 1980, she became intrigued with documenting war-ravaged sites. For twenty years, beginning with Beirut, Ristelhueber has sought out sites of destruction to photograph, including Armenia, Bosnia, Lebanon, Kuwait, and Iraq. She continues to live and work in Paris.

Brutvan, Cheryl. *Sophie Ristelhueber: Details of the World.* Boston: Museum of Fine Arts Publications, 2001.

Hindry, Anne. *Sophie Ristelhueber.* Paris: Éditions Hazan, 1998.

Ristelhueber, Sophie. *Fait: Koweit 1991.* Paris: Éditions Hazan, 1992.

BRADFORD WASHBURN

Born in Boston in 1910, Bradford Washburn was involved in much adventure and mountaineering in his youth, and it brought him to the summits of Mount McKinley and Mount Washington in the U.S. and Mont Blanc, Monte Rosa, and the Matterhorn in Europe. At the age of 17 he took his first photographs from above on a flight around Mont Blanc, spurning a penchant for a career in mountain cartography and aerial photography.

Washburn served as Director of the Museum of Science in Boston for forty-one years and made his sixty-sixth trip to Alaska in 2000. He died in Lexington, Massachusetts, on January 10, 2007.

Washburn, Bradford and Decaneas, Antony. *Bradford Washburn: Mountain Photography*. Introduction by Clifford S. Ackley. Seattle, WA: Mountaineers, 1999.

Washburn, Bradford, and David Roberts. Preface by Ansel Adams. *Mount McKinley: The Conquest of Denali*. New York: Harry N. Abrams, Inc., 1991.

Washburn, Bradford with Donald Smith. *On High: The Adventures of Legendary Mountaineer, Photographer, and Scientist Bradford Washburn*. Washington, D.C.: National Geographic Society, 2002.

Washburn, Bradford. *Exploring the Unknown: Historic Diaries of Bradford Washburn's Alaska/Yukon Expeditions*. Edited by Lew Freedman. Kenmore, WA: Epicenter Press, 2001.

____. *Mount McKinley's West Buttress, The First Ascent: Bradford Washburn's Logbook, 1951*. Williston, VT: Top of the World Press, LLC, 2003.

Sfraga, Michael. *Bradford Washburn: A Life of Exploration*. Corvallis, OR: Oregon State University Press, 2004.

GENERAL BIBLIOGRAPHY

Aston, Mick. *Interpreting the Landscape from the Air*. London: NPI Media Group, 2003.

Avery, Thomas Eugene. *Interpretation of Aerial Photographs*. Minneapolis, MN: Burgess Publishing Company, 1977.

Bertrand, Yann-Arthus. *Earth From Above*. New York: Abrams, 2005.

Crawford, O.G.S., and Alexander Keiller. *Wessex from the Air*. Oxford: Clarendon Press, 1928.

Gerster, Georg. "Abu Simbel's Ancient Temples Reborn." *National Geographic* (May 1969).

____. *Grand Design: The Earth from Above*. Los Angeles: Knapp Press, 1988.

____. *The Past From Above: Aerial Photographs of Archaeological Sites*. Los Angeles: The J. Paul Getty Museum, 2005.

Gerster, Georg, and Charlotte Trumpler, eds. "Threatened Treasures of the Nile," *National Geographic* (October 1963): 587–621.

Goddard, Brigadier General George W., USAF (Ret.). *Overview: A Life-Long Adventure in Aerial Photography*. Garden City, NY: Doubleday, 1969.

Ives, Herbert E. *Airplane Photography*. Philadelphia: J. B. Lippincott Company, 1920.

Jackson, John Brinckerhoff. *A Sense of PLACE, a Sense of TIME*. New Haven: Yale University Press, 1994.

Meinig, D. W. "Introduction." In *The Interpretation of Ordinary Landscapes*. Oxford: Oxford University Press, 1979.

Moore, Kevin D. *Jacques Henri Lartigue: The Invention of an Artist*. Princeton: Princeton University Press, 2004.

Nadar, *Quand j'étais photographe*. Paris: Seuil, 1994.

Newhall, Beaumont. *Airborne Camera: The World from the Air and Outer Space*. New York: Hastings House, 1969.

Phillips, Christopher. *Steichen at War*. New York: Abrams, 1981.

Pierce, Sally. *Whipple and Black: Commercial Photographers in Boston*. Boston: Boston Athenaeum, distributed by Northeastern University Press, 1987.

Ruscha, Ed. *Thirtyfour Parking Lots in Los Angeles*. Unpaginated artist's book with 34 illustrations, 1974.

BOSTON UNIVERSITY
President: Robert A. Brown
Provost: David K. Campbell

COLLEGE OF ARTS AND SCIENCES
Dean: Jeffrey Henderson
Chair, Art History Department: Fred S. Kleiner
Associate Chair, Art History Department: Michael Zell

COLLEGE OF FINE ARTS
Dean, ad interim: Walt C. Meissner
Director, School of Visual Arts: Lynne D. Allen

BOSTON UNIVERSITY ART GALLERY
at the Stone Gallery
855 Commonwealth Avenue
Boston, Massachusetts 02215
617-353-3329
www.bu.edu/art

Director & Curator: Stacey McCarroll Cutshaw
Assistant Director: Marc Mitchell
Senior Security Assistant: Evelyn Cohen
Gallery Assistants: Kaia Balcos, Ben Charland, Seth Gadsden,
Rebecca Hoosier, Paul Kadish, Samantha Kattan, Nilda Lopez,
Karen Ann Myers, Lana Sloutsky, Ginger Elliott Smith,
Natania Remba, and Leann Rittenbaum.

Typeset and printed at The Stinehour Press, Lunenburg, Vermont
Binding by New Hampshire Bindery, Concord, New Hampshire

 Design by Paul Hoffmann